DOOM AND

BLOOM

ABOUT THE AUTHOR

Campbell Walker is the bestselling author of *Your Head is a Houseboat*, as well as an illustrator, animator and content creator, better known as Struthless. His YouTube channel, has amassed over 1 million subscribers and 50 million views across topics such as mental health, sociology and creativity. Cam has worked with Comedy Central, Spotify, Vice, Shopify, GQ, The Betoota Advocate, Tinder, Samsung, Gatorade and Universal Music. Before he pursued his passion – writing and illustrating – Cam worked as an advertising creative director, a tattooist and (for one very strange week) a golf-cart taxi driver at a country music festival in Arizona.

CAMPBELL WALKER
AKA STRUTHLESS

DOOM AND BLOOM

THE CASE FOR CREATIVITY IN A
WORLD HOOKED ON PANIC

Hardie Grant

BOOKS

PART 1
DOOM

PART 2
GROUNDWORK

PART 3
BLOOM

INTRODUCTION

SOME THOUGHTS ON SUICIDE AND THE WEATHER

SUICIDE IS A TERRIBLE PLACE TO START A BOOK. You might be inclined to put it down now, and I might be inclined to draw a parallel between suicide and deciding to quit something you've only just begun. But I wouldn't, because that would be tasteless. And you wouldn't, because you ought to get your money's worth. And besides, one of the tiny little demons in your soul has an insatiable appetite for all things morbid and grim, and that dark demon wants to know where all this suicide chat is going.

Suicide is self-destruction in its final form: the perfect opposite of creativity. Yet despite being opposing forces, self-destructive tendencies and creative flair go hand in hand. To write about creativity and ignore the monster is to not write about creativity at all.

This book is about the Doom that drags us down and the Bloom that makes life worth living. Doom is the feeling when everything is hopeless and hard and you want to die. Bloom is a state of effortless creativity, where solutions surprise you as they flow into reality.

7

The era currently unfolding is one of extremes. We have unprecedented access to information and new ideas, yet also a mental health crisis of staggering proportions. As technology makes life more comfortable and convenient, rates of anxiety and loneliness paradoxically soar. Why is it that what seems like a societal Bloom makes so many of us feel unforeseen Doom? And what can we do about it?

These are the questions this book sets out to answer. We'll delve into why Doom is so prevalent today and discover what we can do to reverse this curse and Bloom through creativity.

Does modern life have you feeling increasingly overwhelmed, terrified, angry, disappointed, nihilistic, confused, left behind, left out, tapped out or lonely? You're not alone. I know what it feels like to suffocate in Doom. To self-medicate to the point of addiction and rack up endless hours on Reddit while my bigger screen fills the remaining gaps of silence with YouTubers yapping about aliens and chess drama. To desperately consume the spectrum of solutions, from convoluted psychological papers with titles the lengths of paragraphs, to patronising self-help podcasts that say things like 'all you have to do is breathe and believe'.

YIKES ALERT!

HE DIDN'T DIE (BUT YOU WILL FROM CRINGE)

But I also know the other side. What it feels like to live in a state of wonder, curiosity, joy, love and sublime creativity. To feel flow so divine you can't help but grin. To be struck by lightning on a bus seat. To bawl at a cheesy pop song because Carly Rae Jepsen sounds so damn happy. And to have your messiest problems solved in a sudden rush of clarity prompted by a single sentence hidden on the eighty-ninth page of an old, neglected library book.

So I'm going to break down the process that has taken me from Doom to Bloom – substantiated by modern research, ancient philosophy and an unclassifiable range of anecdotes – and distil it into actionable steps and a pretty wacky metaphor.

On that note of positivity, let's talk about suicide …

I've wrestled with suicidal ideation for most of my life. When I was seventeen, I gave it a shot. If suicide attempts had critics the way movies do, a critic might call this one 'over the top'. I drove my mum's Honda Odyssey into a tree. 'No subtlety,' that movie critic would write. 'The crash itself, bloated and verbose, still manages to be painfully anticlimactic. Not only does he destroy his mother's car and survive, but it's as if he learns *nothing*! Any gratitude you'd hope the protagonist might feel for having survived the wreck is sorely missing. The most suicidal aspect of Campbell's entire attempt will inevitably be the audience as they search for something better to do with their time.'

Not to ruin the ending, but I survived.

We're taught that suicidal ideas are extreme, fringe, abnormal, ill, selfish, taboo, uncomfortable, uncommon, fake, ungrateful, romantic, toxic, indulgent, ignorant, insane and wrong. This seems like a lot of baggage to place on what seems like a lot of baggage.

Perhaps the idea is that judgement will act like a deterrent. The logic, I guess, is that being labelled 'attention-seeking' will make killing yourself … embarrassing? Or maybe it's an honest attempt at a self-fulfilling prophecy: if we pretend suicidal thoughts are rare, then suicide itself will become rare. Or perhaps it's more superstition, like stories of monsters summoned by the mention of their name. If we say 'suicide' five times in a mirror, will it suddenly appear like Candyman? Or will we just make a profoundly isolating experience feel even lonelier?

When someone dies from suicide, it's as though their pain is redistributed from their soul to all the people who'll miss them. The misery, victorious to a fault, finds new company in us. We, who'll forever regret not making that call to catch up, who'll replay countless conversations as though we had the power to change them, who'll keep their name and number in our phones and 'accidentally' scroll past them on our way to someone else. We, who'll spend the rest of our lives wondering what we could have said to make them stay.

If you've ever lost a friend to suicide, which sadly applies to more and more of us these days, you'll know the torture of the aftermath. You'll know the shock, anger, confusion, regret, fatigue, and that the phrase 'time heals all wounds' is at best a bumper sticker.

GOTCHA

I loved my friend Tinman (whose real name we'll leave in peace). We were close friends – best friends at times – for twelve years. His funeral was confusing. His family, his playlist, and the friends of his I'd only ever see at birthdays and weddings: they were all there. My mind knew all these things to mean Tinman, so I kept expecting him to show up and say, 'Gotcha!' But, instead, Tinman was dead and would stay dead for the rest of my life, despite whatever divine bargains my brain pretended were real.

Seeing his mum outlive him broke my heart. I hugged her like she was my own mum and wept. 'You're crying more than me now!' she said, laughing sincerely.

She laughed because if she cried she'd have to cry for all of it. I only had to cry for twelve years of friendship. She'd have to cry for losing her perfect baby, and for all the memories of cuddling her toddler in bed, for his first day of school with a backpack twice his size, for Christmases, for birthday parties, for the terrifying teenage years, the drum kit, the guitars, the eyebrow piercing that definitely wasn't a phase, for the rock-climbing wedges he installed throughout the house, for coffees and crosswords, for the man her son became, and every tiny detail in between. And then she'd have to cry for all the things she wished had gone a different way. So of course she laughed.

'All these people,' she gestured at everyone Tinman had known, 'all their lives were made better by my son.'

It's true: Tinman made my life better. But not all the time. There were times he talked too much on road trips, times he made it hard to help him, and times he didn't deserve the aux cord. But that's the deal with friendship. If you want a friend to change your life, you've got to let them in, not just when they're a well-oiled machine but when they're down a heart and calcified in rust. And hopefully you can tell them that you love the rust too.

Tinman was as full of pain as he was spark. The pain had him convinced the world only cared about the spark.

It had him believe that if anyone ever saw the pain, they'd have undeniable proof of his worthlessness and reject him on the spot. So, to ensure this never happened, he made the spark as big as humanly possible. He lit up rooms like a walking sun. He was bright, warm and always welcoming, yet he somehow found a way to make sure no one ever stared at him directly.

This is to say, Tinman was the most charismatic person I've ever met. I know you might have some scepticism reading that, because of course I'd talk about my dead friend in a nice light. I have to, right? But this isn't a posthumous observation. I – like everyone he'd ever met – had been saying this for years. He was charm incarnate. To make matters worse, he was frustratingly handsome. The bastard even had the audacity to play every instrument under the sun, have a mental library of well-crafted stories, drive a cool car, crack vibe-appropriate jokes and, it pains me to report, he was also shredded. Tinman was the first person I knew to do CrossFit, and oh my god, did he go on about it.

All these qualities (minus the gym-preach) made him a magnet for women. Tinman was broken, so he treated this love like a drug. The more he got, the more he wanted, the worse he became. There were times when this was unbearable to witness as a friend. He'd destroy a relationship with a woman he truly loved, start three more the next day, and continue the other two relationships he'd kept secret for months. He was horrible, in this sense. But I struggle to judge him as harshly as I perhaps ought to, because to me it was clear his behaviour was a symptom.

For reasons I may never know, I *did* stare directly at the sun that was Tinman. And for reasons I'll definitely never know, he let me. Instead of burning my retinas, there was a black hole at the centre of his soul that had been there since childhood – the kind of wound that happens far more than society would like to admit, and a wound that I share: one that set in motion a life of misery masked by adventure. He never recovered. He just kept moving. But this curse caught up with him, as formative horrors so often sadly do.

Tinman's main coping strategy for the pain that plagued him was to block it out. He projected the idea that his life was perfect as if doing so would make it so. But this mask dropped every time he made stuff.

One time our band played a gig on Halloween and we dressed up as the characters from *The Wizard of Oz*. Tinman of course picked the Tinman. Dressed as a guy who had no heart, singing songs about his own numbness, Tinman let it all out. Through art he was able to express himself truthfully, and in doing so he felt fulfilled. Something about creating songs allowed him to drop his guard.

TINY HAPPY SEEDS

We've all had times when we've felt our spark fade. When happiness seems out of reach, by miles or by millimetres, the natural response is to adapt and keep on living. We lug around invisible weights, go through the motions of our day, smile, wave, and wonder if this is as good as it gets. The longer we live in this state of slow erosion, the more it feels like the only state there is. Sometimes we need a miracle to snap us out of it, other times it takes a tragedy. And sometimes, the sudden clarity can shock you into writing an entire book.

I delayed writing this book for two years while I discovered just how urgent laundry and dirty dishes can become. After my first book was published, I tried to write another before becoming a dad. I did, but I didn't like the manuscript enough to submit it. Then my wife and I had our hands full falling madly in love with our daughter.

Instead of making stuff, I engaged in a whole lot of *not* making stuff. At first, it felt harmless, as though I was just creating a little less. Then, I stopped drawing altogether. 'Big deal,' I thought. But this invalidating attitude wasn't

quite enough to sabotage my craft; I also had to hate myself. Thankfully, I'd had plenty of practice. My ten thousand hours of self-flagellation made for a seamless transition into an unremarkable depression. The not-so-seamless transition out of this sadness came with a phone call.

'Hey, Cam.' It was Tinman's brother. When a friend's brother calls you out of the blue on a Saturday night, you pray it's for a poorly organised surprise party. 'Bit of bad news ...' My first thought was that Tinman was in hospital. Before I had a second thought, he told me that Tinman had died a few hours ago in a self-induced car crash.

A few days later, Tinman's brother asked me to create some artwork for the funeral. I felt honoured, which was much nicer than anything else I'd felt recently. Without thinking, I was drawing again.

I drew an artwork dense with references to Tinman's life. Every time I finished a section, I felt an urge to photograph it and send it to Tinman, because I kept thinking how much he'd love it. Every time, it took a second before I remembered he was meant to be dead, and another second before I realised he actually was. My brain had added a step in between where we were all pretending, rehearsing for a tragedy instead of being stuck in one.

Lost for what to make of it all, I just kept on drawing.

If, after suicide, one person's pain is redistributed in pieces to their friends and family, the joy that person brought to the world does something similar. The inspiration, the spark, the wonder, the brilliance, it also needs a new home, and there's no one more deserving than the people who loved its former host. All their qualities, like pollen floating in the ether, make their way to you. Tiny happy seeds get planted in your soul and start to grow.

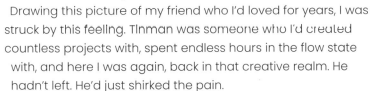

Drawing this picture of my friend who I'd loved for years, I was struck by this feeling. Tinman was someone who I'd created countless projects with, spent endless hours in the flow state with, and here I was again, back in that creative realm. He hadn't left. He'd just shirked the pain.

Doom had already made itself at home. But Bloom was still within reach.

The key is creativity.

Not the arts, but creativity: the opposite of destruction.

The thing that connects the dots and lets your mind go free.

CULTIVATING CREATIVITY

I've long believed that creativity is our highest and most natural state; that unless we actively spend time in the creative state, we'll default to the destructive one. And I've also long believed that the more capable of creativity you are, the more capable of destruction you are. My entire life has been hallmarked by these two forces: destruction and creativity. Doom and Bloom, for short.

Only one force can sit in the driver's seat at any one time. And you can fool these forces into *thinking* they're driving. Destruction can be calling the shots while you convince your creativity that it's on display. There's no shortage of tortured-artist stereotypes to prove this. But you can also let creativity take the wheel. You can trick your destructive side into believing it has an equal say, but we'll both know who's driving.

The more you get to know these forces, the more you learn to use their power. Destruction stops being shameful and instead becomes potent fuel for growth. Creativity stops being stubborn and instead becomes your nature. And we can lay the Groundwork to make that happen.

This model is what I call Cultivated Creativity. Just as flowers Bloom from fertile land, we can cultivate our lives in such a way that ideas have no choice but to blossom out of us and despair is left sitting on the sidelines.

My friend Tinman was outrageously creative, but in the end destruction took the wheel. My aim with this book is to stop another crash.

This book you're about to read is split into three parts. I encourage you to experiment with the ideas and create a framework that works for you. To make the process clear, we'll be using the central metaphor of a lush, majestic garden ... except we won't be starting there. We'll be starting with an arid wasteland where that garden was supposed to be!

Doom is about pulling ourselves back from the brink of burnout and simply getting unstuck in life. Our first task isn't to plant seeds but to make sure the land doesn't get any worse. With dead trees and dry leaves, it'd only take a single spark to burn the whole thing to a crisp. We'll cover the conflict between our outer world and our inner world, and how smartphones, sensationalism and social media have created a sense of Doom – so we can work out what to do about it.

Once we've made this little world less flammable, it's still not quite time to plant seeds. We next have to make the earth conducive to growth. This is Groundwork. We've quelled the immediate fire hazards, but we want to make the change permanent. We want to design a lifestyle where new seeds – or new ideas – grow by default. We'll cover how to build a life that makes creativity effortless and fulfilling, and tactics for turning all the shit we've been dealt in life into fertiliser for growth.

Once we've done the Groundwork, now it's time to Bloom. We shift our focus from surviving to thriving, and finally get rewarded for all the hard yards we put in earlier. Your creative practice is the result of four big skills working in tandem: curiosity, focus, catharsis and rest. In our garden, these four states will be represented by the four seasons. There are different phases of creativity, and they all serve each other in the name of growth.

BLOOM

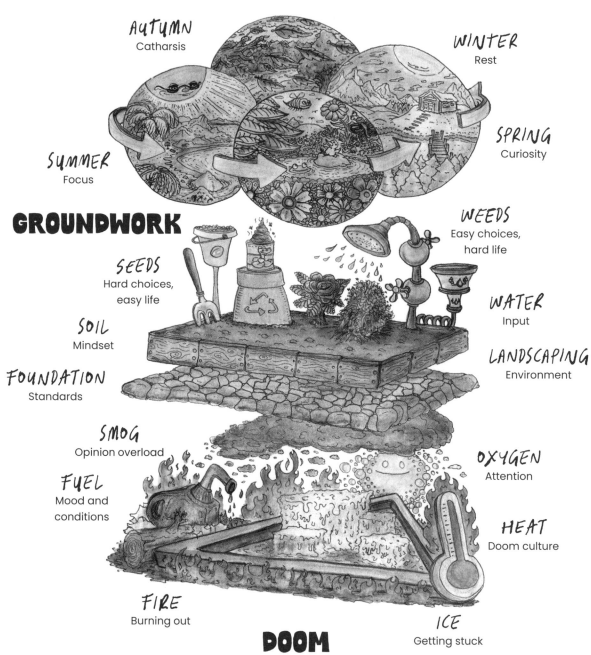

AUTUMN — Catharsis

WINTER — Rest

SUMMER — Focus

SPRING — Curiosity

GROUNDWORK

SEEDS — Hard choices, easy life

WEEDS — Easy choices, hard life

SOIL — Mindset

WATER — Input

FOUNDATION — Standards

LANDSCAPING — Environment

SMOG — Opinion overload

OXYGEN — Attention

FUEL — Mood and conditions

HEAT — Doom culture

FIRE — Burning out

ICE — Getting stuck

DOOM

Speaking of *The Wizard of Oz*, do you remember what Dorothy learns at the end of her journey? She's told that the power to go home was with her all along. Those nifty slippers she's wearing aren't just for the aesthetic. Like a ruby-red rideshare app, they take you home after a few taps.

The 'it was with you all along' trope has since become an easy way for writers to finish their work. So I thought it would be a nice place to start.

Whether you're a seasoned artist or a self-defined basic person who loves *The Bachelor*, creativity is within you. If that sounds corny and patronising, wait till you read my next sentence. You have the power to create anything you want to in this world, with the right systems, environment and mindset. Wow. Take notes, Tony Robbins.

I'm not just talking about making things that are overtly recognised as creative, like albums and sculptures, but the ability to create *anything*: meals, jokes, friendships, babies, money, sweet gains at the iron cathedral. Most of the things that make life rich are generative processes, and yet 'creativity' is often talked about as though it's some rare mystical birthright, available only to a fraction of the population.

Creativity unlocks our potential in all areas of life, not just in artistic endeavours. Generative mental habits can spot financial opportunities. Lateral thinking can solve a fitness goal. And the flow state serves as a remarkable antidote for the angst that haunts our species – not to mention the angst-multipliers that plague our time.

The aim is to make the creative state accessible, additive and fulfilling, even if it seems like you're in the pits of hell. In the bluntest way possible: if you're feeling like absolute dog shit, the purpose of this book is to get you creating stuff, not necessarily for the sake of producing any specific output but for the headspace it puts you in.

One reason I am writing this book is to help heal me. I hope, or more accurately, I suspect, that it will. And I suspect, or more accurately, I hope, that reading these words will help you too. I hope that through this book you find a way to treat your creativity naturally, with love, so that it stays with you and you stay with it. And that through this process, you don't destroy yourself but instead you Bloom.

—CAM

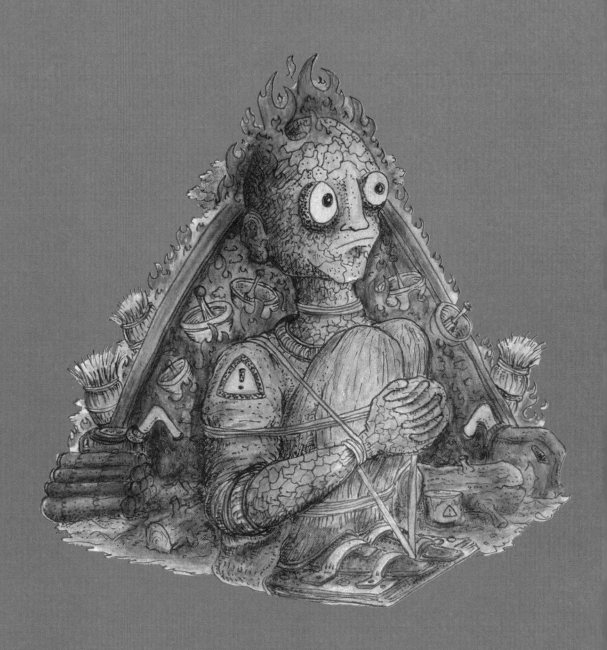

DOOM

CREATIVITY IS AN ABSTRACT CONCEPT, which makes understanding it tricky. It often suggests a highly specific set of executions: paintings, music, poetry, sculpture and, occasionally, beatbox. But these executions are to creativity what bicycles are to transport. Some people might not like riding a bike, but everyone has somewhere to go.

Creativity, as we'll see, fits closer to the modern understanding of a person's soul. Or, for those of us with allergies to words like 'soul', the operating system on which our brain computer runs. It is our drive to create anything – buildings, people, language, art, theories – and sits in stark opposition to our drive to destroy.

One of the most enduring pieces of human wisdom, stumbled upon time and time again, is the importance of balance. Yin and yang, enantiodromia, relativity, peaks and troughs, boom and bust. While the genius of Dynastic China and the timelessness of the Ancient Greeks are both on the menu, my favourite iteration of this concept comes from an ad I saw in the early 2000s for something called Le Snak.

Le Snak is an Australian lunchbox staple: a sna(c)k, as the name suggests. Unburdened by health star ratings, Le Snak gives you three crackers and a small plastic compartment full of liquid cheese in which to dip them. Individually, neither component was much of a snack at all. The crackers were dry and the 'cheese' was questionable, but together the legacy of Le Snak was forged, with the tagline: 'You can't have one without le other.'

Life is a dry cracker and death is a questionable cheese dip, unpalatable apart and dull in isolation, yet somehow perfect when combined.

This might help explain why so many cultures use contemplating death as a vehicle for appreciating life. Hyolmo Buddhists offer the phrase 'chiwa mitakpa' to remind them that life is defined by death (chiwa) and

impermanence (mitakpa). Woven into the teachings of Islam is 'Tadhkirat al-Mawt' (the remembrance of death), inseparable from the Stoics are the words 'memento mori' (remember you must die), and Mexico's Día de los Muertos turns death into the kind of festival that makes people feel alive.

In the words of Albert Camus, 'Come to terms with death, thereafter anything is possible.' And in the words of Le Snak, 'You can't have one without le other.' To comprehend creativity, we must comprehend its 'other'. In modern life, this takes the form of a mindset that, in the face of uncertainty, habitually defaults to cynicism, apathy or total Doom.

To be clear, I don't blame anyone for having this mindset, nor do I find it irrational. A glance at today's headlines, a mirror that doesn't show you perfection or the rising prices in the supermarket are enough to send anyone's mind to the 'other'. Defaulting to Doom makes sense, but it's not the only option.

8. And then we can start to garden.

7. That leaves us ready to do the Groundwork that makes gardening possible.

6. Create stable foundations.

5. Break through the ice that keeps us frozen and stuck.

4. Stop inhaling second-hand smoke.

3. Pull ourselves away from the flames of burnout by dealing with our level of fuel, oxygen and heat.

2. If we want to see any growth, we have to make changes ...

1. How do you get a garden to Bloom in Doom-filled hell?

GARDENING IN HELL (YOUR MISSION)

Imagine hell on Earth. Think of a molten lava lake, a tornado of desert sand whipping about, and a plain of jagged rocks. Our aim, through this book, is to turn this world into a gorgeous green garden.

Each harbinger of Doom is like a new environmental obstacle that stands in the way of growth. Six hours of daily screen time, for example, is a heavy sandstorm. The 'you're gonna die tomorrow' headlines are like geysers blasting out boiling steam. The constant exposure to fringey psychopaths is like salt scattered upon the earth.

Whether you want to grow a garden in hell or nourish yourself in a world hooked on panic, we're going to need to do some serious work. We want to grow, but the atmosphere is against us.

We live in an ambience of Doom that has been propagated by the media we now use to communicate. This Doom is gradually boiling water and we are

all frogs. Some frogs notice before others, but – whether we admit it or not – we're all feeling a bit more heat than we can handle.

I am referring to the climate of discourse, the media in the internet age, and how exposure to sensationalist information affects our mental health. I am not-so-subtly gesturing towards the normalisation of hyperbole over facts, the fallout from social media, the anxiety caused by smartphones, the unhealthy subjection to horrible things you have no control over, the disproportionate airtime given to extremist nutjobs, the constant status comparison that comes with being globally connected, how your biases get hijacked for profit every day, the implication that systemic problems have no answers, and the feeling that whatever you are is never quite enough!

But just as weeds break through concrete and oases form in the desert, so too can we Bloom in a world addicted to Doom. And in doing so, as our garden inspires others to grow, we make everything a little nicer for everyone else.

We'll kick things off by questioning Doom altogether.

ARE WE DOOMED?

Doom is what happens when we conflate the unknown with catastrophe. It's asking, 'What could go wrong?' rather than, 'What could go right?' The idea is that if you don't know, your best bet is to assume the worst.

What percentage of the world are refugees? How bad is our climate change outlook? And how many people fall into extreme poverty every day? If you don't know the answers, Doom suggests you err on the side of horror. Better to be cynical and pleasantly surprised than look like a privileged, naive dummy.

But the more we look at this Doom, the more we see that it's not only wrong but actively damaging.

The answers to the above questions have been provided by three academics and self-confessed ex-doomers:

* According to Jodie Jackson, founder of News Literacy Lab, from her 2022 TEDx Talk, refugees make up just 0.5 per cent of the world's population. (The journalist maxim 'if it bleeds, it leads' may be responsible for the fact that most people guess the percentage to be much greater than this.)

* Climatologist Michael Mann, famous for the hockey stick temperature chart that kicked the world into gear, said in an interview in 2023 that, post the 2016 Paris Agreement and thanks to progress in adopting renewable energy sources, global temperature increases may stabilise around 3°C or even 2°C, instead of the previously estimated 4°C.

* Author and environmental scientist Hannah Ritchie offered a jaw-dropping statistic in her 2024 book *Not the End of the World*: that over the last twenty years, '130,000 people have *escaped* extreme poverty' every single day. That's close to one billion people.

Make no mistake, these are still horrible and urgent problems. But believing that these problems are insurmountably large is no strategy for solving them.

Over the next fifteen years, do you think people around the world will be better off or worse off? This is a question that has been asked in over 200,000 interviews across forty different countries since 2012 as part of an ongoing Ipsos project called The Perils of Perception. Curious about the gap between perceptions and reality, researchers set out to examine 'why people around the world are so wrong about things like causes of death, climate change, the sex lives of young people, immigrant numbers, overcrowding in prisons and much more'.

In addition to asking if the world will be better or worse in fifteen years, people were also quizzed on their knowledge of global development. The study found that the more people knew about the world, the more optimistic they were about our future. The less people knew, the more they thought we were doomed.

If cynicism and catastrophising make matters worse, why have they become mainstream? To answer this, let's look at incentives.

Who benefits when we believe the world is burning and there's nothing we can do? It's not the victims described in the message. It's not the person who receives that message. The real winner is the messenger – whether that's an authoritative news source, an unhinged streamer, or even a budding cult leader. By painting a horrible picture of the world, they win our attention. When attention is currency, this race to the bottom becomes a worldwide shitfight.

To understand it better, I'd like to take a trip back a few hundred years – because we're far from the first people to think the world was doomed.

RENAISSANCE OR SHITALY?

If you had to name a chunk of history that best embodies Bloom, I imagine many people would say the Italian Renaissance. Dial the clock a century or two earlier, however, and you might find – without even leaving the country – a chunk of history that best embodies Doom.

For the non-history buffs, I promise this is going somewhere. For the rest of you, get excited for a trip to pre-Renaissance Italy!

To narrow our scope to a century of Doom, I'd like to focus on the hundred years that took place between 1250 and 1350, which we'll hereon refer to as Shitaly. On the surface, daily life in Shitaly looked nothing like life today, but dig a little deeper and we start to find some uncanny parallels. While the Renaissance reflects the explosive societal shifts we've *seen* in the twenty-first century, I'd argue that Shitaly is a much better mirror for how it all *feels*.

So what made Shitaly so, well, shit?

For starters, it wasn't even Italy yet. In the mid-thirteenth century, the area we now call Italy was split into over sixty independent states, and the violence between them was relentless. In one particularly deadly battle in 1260, 10,000 men were killed and 4000 men were declared missing on just one day. Then, in the fourteenth century, there was terrible weather: Earth was enduring its Little Ice Age, which brought freak natural disasters and devastating crop shortages. Across Europe, the Great Famine took millions of lives, with some historians estimating cities lost up to one quarter of their inhabitants. The Black Death would later kill a third of Europe's population. This plague hit Italy in 1348, the same year as a gargantuan earthquake. In Italy's north, the Friuli earthquake took 10,000 lives and its tremors were felt across the continent, inciting thoughts of rapture and revelation.

If that wasn't enough, Shitaly lost its grip on being 'The One and Only Home of The Pope'. Popes traditionally weren't meant to get political, but try telling that to Boniface VIII, a nutjob who had recently discovered the joys of tax evasion and war. On a societal level, he catalysed military campaigns that killed thousands. On an individual

level, he reportedly kicked a diplomat in the head one time. When the king of France asked the church to pay taxes and follow the law, Boniface responded by excommunicating him. Being a medieval ruler, the king 'paid the pope a visit'; he nearly killed the 73-year-old Boniface, who died a month later. Peace did not ensue.

Then there's technology. When it comes to inventions, thirteenth- and fourteenth-century Italy was no Silicon Valley. The challenge of not dying was understandably more pressing. But by contrast, the Chinese Empire spent this era inventing everything from a proto printing press to an explosive new material that was about to make a bang. Gunpowder would soon take the gruesomeness of war to new heights.

So we've got climate change, wars, pandemics, scarcity, environmental disasters, corruption, fractured nationalism, the loss of faith in religious institutions, income inequality, being at the mercy of nutjobs with unimaginable political power, and rumours of exotic technology that can kill you with the click of a button. Sound familiar?

We have our fair share of equivalent challenges in the twenty-first century, and it naturally leads to a feeling of Doom. Granted, we also have modern medicine, space travel, open information, diplomacy and Le Snak. On paper, our era is far more like the Renaissance than the bleak centuries of rubble it rose from.

So why does it feel like the world could end tomorrow?

One argument is because it could. A terrorist passionate about microbiology and massacres could engineer a virus to eradicate our kind. An angry politician could rage-quit humanity with the full force of nuclear bombs. Or maybe the simulation will throw a curveball and send in some aliens.

However, Armageddon being in arm's reach isn't exclusive to today's world. Traces of apocalypse fill the Bible, natural disasters are time-agnostic, and the bubonic plague was as real as threats get. What sets our era apart is exposure.

A fourteenth-century Italian saw their home and immediate surroundings. Thanks to the internet, we see our entire world. We both see an endless stream of existential risks. For the fourteenth-century Italian, Doom was everywhere they looked IRL. For us, even if it's not directly affecting our lives, we can still stare at it for seven hours a day on our phones. And once you see a monster, you can't un-see it. We're not wired to forget train wrecks; we're built to burn them into our brains. Soon, we completely fill our heads with horror, until it's all we think about.

So what do we do about it?

TO FLAGELLATE OR NOT TO FLAGELLATE

One movement from Shitaly offers a haunting suggestion. In 1259, following a brutal famine, a group from Central Italy responded to the Doom they saw around them by whipping their own flesh in public, kickstarting the movement known as flagellantism. The flagellants assumed wars, famines and plagues were divine punishment and that the best course of action was to beat themselves up about it –

literally. They hoped their god would see how sorry they were for their sins, take mercy on them and stop the torture.

With our modern understanding of climate, politics and diseases, the flagellants seem quite tragic. Not only did they not cause the Doom, but their solution only made things worse.

In torturing themselves so publicly, the flagellants of 1259 became predictably tribal. With every performative lashing, they became further convinced of their doctrine and accused anyone who didn't join them of being part of the problem their pain was trying to fix.

Such a response is all too human. When we see today's Doom, we might not whip ourselves in the streets but we still find ways to internalise it. We put ourselves through emotional pain. We see climate change and think, 'Why bother creating anything if the world is ending?' We see wars and suffering and conclude that chasing personal joy is somehow selfish. If you feel like you can't fix a problem, it's easy to decide that the next most noble move is self-flagellation.

When this happens in the form of a public movement, modern self-inflicted Doom becomes equally tribal. Anyone who refuses to join the group in torturing themselves is accused of being part of the problem.

When ideological extremists clash in toxic comments sections, we often get a glimpse of the same persecution fetish. The same with-us-or-against-us mindset, performative punishment and transactional charity. This flagellant response to Doom is as present now as ever.

All it did was go online.

WHAT WOULD DANTE DO?

Abandon all hope, ye who enter here.

DANTE ALIGHIERI

The other answer to the question of how to respond to an overwhelming sense of Doom can be found in the life of an individual from this same vexing span of Italian history.

Dante Alighieri, fashion icon turned poet GOAT, was born in the swinging 1260s, and his life was as hard as the times. His mum died before he turned ten, his dad died before he was twenty, and the woman he considered his muse died shortly after. Just as Dante was catching a break, starting a family and building his literary career, he got exiled from his own city.

Wandering around an unstable Italy, the unstable Dante had every reason to self-destruct, but instead he turned to creativity. While in exile, threatened with being burned at the stake if he saw his children, Dante began to work on a poem that today is regarded as one of the greatest pieces of literature in the Western canon.

Dante's epic trilogy *The Divine Comedy* is an allegorical odyssey from sin to salvation. Over the course of three poems, 'Inferno', 'Purgatorio' and 'Paradiso', Dante traverses the pits of Hell, climbs the earthly mountain of Purgatory and visits god in Heaven.

Dante's work is often argued to be the first piece of (proto) Renaissance art. Think of him as the first evidence we have of medieval Italy's Doom culture changing to a Bloom culture. And I don't think it's coincidental that Dante's poem ends in the heavenly promise of 'Paradiso'. At the risk of calling

The Divine Comedy a self-help book, the whole thing is laced with implications about improving yourself to improve the world around you (which is why it's going to pop up again a few more time in *this* book). Dante planted the seed of this philosophy in the dirt of his day, and over time it began to grow.

In our modern lives, when thinking about how to turn our current climate of Doom into one of Bloom, who better than Dante to use as a role model? When the world feels like hell on Earth, the only way is through.

LIVING THAT HIGHLY FLAMMABLE LIFE

Imagine you are standing in a field covered in gunpowder and petrol-soaked kindling. The summer sun is beating down on you and a dry breeze is blowing tumbleweeds past a lake full of lighter fluid. If someone lit a match here, you'd be toast. Thankfully, no one has done that yet, but the second there's a spark your world will become a raging inferno.

Feeling as though you're constantly a bad day away from complete burnout is sometimes how it feels to be alive in the twenty-first century. To get a better grasp on why this is, we'll use the analogy of a fire.

A fire needs three conditions to burn: fuel, heat and oxygen. These three, according to the fire-safety possum who routinely visited my primary school, are called the fire triangle. Light a match in a dry forest on a hot day and you'll get a fire. Take away any of these three elements and you douse it. Remove the oxygen around a candle and watch it die. Drench an ember with cool water and see it vanish. Take the logs from a fireplace and the flames will fade into ash.

In our hellscape-to-garden metaphor, we have conditions that are ripe for fire.

Firstly, fuel represents how you feel at any given moment. On a bad day, your sensitivity to open flames is at its highest, just as a pile of dry leaves is a wildfire's best friend. If you're in a great mood, it's far harder to set you off. Next up we have oxygen, which can be best understood as attention.

Without our attention, modern-day panics cannot stay alight.

The heat in this equation is the Doom culture that surrounds us. From the constant noise of the internet to cost-of-living gouges, this heat, like the heat of the weather, is the part we have least control over.

Over the next few chapters, we'll look at how each of these elements affects you, as well as what happens when hordes of people around you are ablaze and billowing smoke.

OXYGEN

Your attention: vital and inseparable from life itself ... which makes it all the more deadly when exploited by arsonists

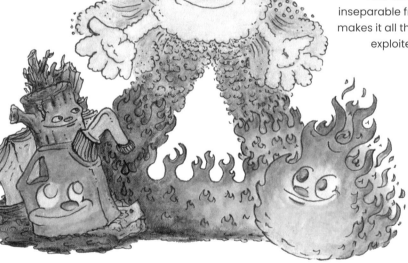

FUEL

Your state of mind: which can on any given day be the difference between shrugging off and exploding

HEAT

Our Doom culture: the collective fatigue of all our brains enduring constant digital assault (in addition to all the other cultures you personally participate in)

DOOM OR BLOOM?

A few quick questions to figure out where you're at. Give yourself 1 point for each 'yes' answer. The higher you score, the more you're in Doom or Bloom.

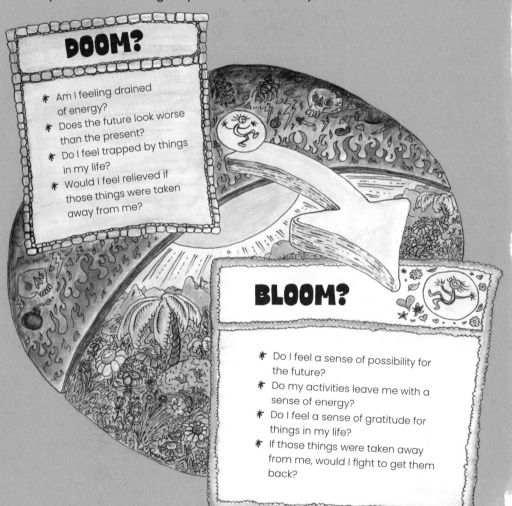

DOOM?

* Am I feeling drained of energy?
* Does the future look worse than the present?
* Do I feel trapped by things in my life?
* Would I feel relieved if those things were taken away from me?

BLOOM?

* Do I feel a sense of possibility for the future?
* Do my activities leave me with a sense of energy?
* Do I feel a sense of gratitude for things in my life?
* If those things were taken away from me, would I fight to get them back?

CHAPTER 2

FUEL
(YOUR SELF)

If you've gone through periods of your life on the verge of flames, you might be familiar with how emotional fuel plays out. The tiniest thing can set you off. You get hit with an unexpected bill, receive an unpleasant email or hear an ungrateful remark, and you feel yourself go up in flames. Sometimes you recover, remind yourself that it's just a hiccup and get back to enjoying your life. Other times, when life's lemons are particularly sour, this one tiny spark sets off a chain reaction. The conditions of your life make sure that a dropped cigarette becomes a forest fire.

MIKE AS A FIRE

For me, this story starts with my brother-in-law Mike, my wife's twin. Mike is integrity in human form. He's honest, inquisitive, wickedly funny, occasionally goofy, always outdoorsy, and takes way too long to explain board games. We love Mike.

For years, Mike worked as an engineer. He adored the mathematics and hated pretty much everything else. What began as a love of numbers was now a Sisyphean slog of sixty-hour weeks, battling bozos and bureaucrats to tick off tedious tasks, all to make someone else a bunch of money.

Naturally, Mike burned out.

If we look at Mike's situation in the language of our fire metaphor, we can see why. The workplace was his heat. Mike's days were spent in its sweltering atmsophere. His attention was rerouted from his passion for problem-solving to surviving micromanagement, as though the oxygen he once inhaled was forced to feed a fire. And the long days, the constant belittling, and the beers he drank to unwind added up to form the final element: fuel.

Mike's fuel was piled high. Combined with the excessive amounts of heat and oxygen, all Mike needed to trigger burnout was a teeny spark. That catalyst came in the form of a single-digit-IQ co-worker making a routine passive-aggressive remark. This straw broke the camel's back, then set the camel on fire.

However, you'll remember, Mike is integrity in human form, so his burnout – to an outside observer – looked composed. He politely nodded at the idiot, respectfully quit his job, and made sure he was well outside the premises before having a total mental breakdown.

As the weeks rolled on, Mike began to recover. Without the toxic culture, there was less fuel to burn. Without workplace politics oxygenating the flames, he was able to turn his attention to things he loved, like footy, coral reefs, and the history of calculus. And with more time outdoors and moving, his life cooled down to a delightful room temperature.

The only downside was that he was unemployed. But with a cooler head, Mike could make a clearer decision. He realised that the fundamental problem with the engineering job was that it was meaningless. All jobs have moments of stress, but not all jobs serve a purpose that makes that stress worth enduring.

Mike knew he could stomach any job's downside if he felt he was making some sort of difference. And so, Mike became a high-school maths teacher – and an absolutely brilliant one.

Fast forward a few years and Mike is loving his new life. Then one day, Mike got hit with the mother of all fire-starters.

Mike got a threatening phone call from the government.

WHEN SPARKS FLY

Mike, like lots of students, had been on government payments. Now, an automated government message was telling him that he had been overpaid. Apparently he owed the government $6000.

An aggressive email confirmed that it wasn't a scam, and that he did in fact suddenly owe thousands of dollars.

The standard reaction to being told by a government agency that you owe them thousands of dollars is a sense of panic and hopelessness.

Mike had a different reaction. He wasn't the kind of guy who forgot about debts, let alone $6000 debts to the government. As a former engineer, Mike was suspicious of automated systems, and numerical discrepancies turned on a tiny little troubleshooting oil light in his brain. As a maths teacher, Mike did the maths. Arriving logically at incorrect answers has a name: error carried forward, or ECF. A common culprit of ECF starting with the wrong data. Operating from this assumption, Mike figured out a way to arrive at the figure he allegedly owed.

He called up and explained their error to the agency, walking them through the ECF. Their formula made sense, but the numbers they plugged into it were simply wrong. After a long and teacherly explanation, he convinced the operator to check the numbers (which he was right about) and wipe the debt.

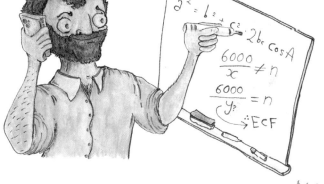

But Mike wasn't the only one getting these phone calls and emails. People across Australia were suddenly learning they were in debt thousands of dollars to the government. But unlike Mike, most people don't reflexively check for an ECF. Most people, understandably, were overcome with panic and hopelessness. Particularly if the fuel was piled up in other areas of their lives.

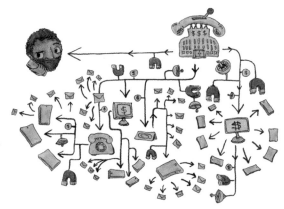

These unlawful automated government debt accusations would come to be known as the Robodebt scheme. It all began with an internal program designed to work the way Mike's oil light did. If someone's tax statement didn't match their Centrelink statement, the program would flag their case. The flagged file would then be checked by a human, and a significant chunk of these flags were false alarms. One number was calculated annually, the other fortnightly, which made false positives commonplace and human checks crucial.

Then the government made two really bad decisions. First, they got rid of the human check to save salary costs. Second, they let this internal flagging system loose on the public. If a case was flagged, the machine would skip straight to emailing and calling a real person to tell them of their new debt. In the name of efficiency, they harassed and threatened people until they paid.

When conversations about automated technology stray into lofty philosophical territory, you'll inevitably come across the paperclip problem. An AI bot is given the benign goal of making paperclips. Seems tame enough. But with its superior intelligence, the machine learns that the most efficient way to make paperclips is to rearrange the atoms in your body. In trying to serve an innocent goal, it turns humans into paperclips. We're meant to be appalled that a machine could be so callous. We're meant

to balk at the idea of an entity that sees people as nothing more than fracking potential – as if we don't see it every day.

AI models are trained only on the parts of ourselves they can access. Instead of watching us fall in love, they watch our clickbait. An AI trained on hot takes and snarky tweets is a turbo-powered time waster. An AI trained on radicalised communities and doxing forums is a superintelligent hate machine. And an AI trained on the cold behaviour of an efficiency-hungry government is a paperclip time-bomb waiting to explode.

The fault lies not in the machine, but in the people who deployed it. The fears we have of powerful technology falling into the wrong hands are as primal as Prometheus. Humans make the error and their tolls just carry it forward.

When the government was told of the erroneous debt accusations, they kept the program running, determined to turn more people into paperclips at any cost. The cost, in question, was the mental health of the human on the other end of the phone.

Some reports say more than two thousand people committed suicide as a result of the Robodebt scheme. Other reports say the number was as few as three. The wide window might be the result of one number coming from grieving members of the public and another number coming from career politicians looking to exonerate themselves in court. In any case, no report says it was zero. There are also countless harrowing personal stories that ended in other types of tragedy, such as single parents left in debt to loan sharks after attempting to pay off their (non-existent) government debts. For these people, this was the spark that set that fuel on fire.

WHAT'S THE POINT?

Why did I tell you this story? Is it just to twist the knife into the Australian Coalition Government and remind the world that blood is on their hands? A little. But mostly it's to illustrate how the conditions of our life interact with the unexpected shit that flies our way.

Triggers, catalysts and sparks fly at us constantly. We can't control the hands we're dealt.

Traditional self-help rhetoric says that my next sentence should be, 'But we can control how we respond.' However, between you and me, that's a big ask. Yes, Viktor Frankl did it to find meaning in a concentration camp. Yes, Malala Yousafzai did it to turn attempted murder into a Nobel Peace Prize. And yes, Nelson Mandela did it to endure twenty-seven years in prison only to come out the other side and abolish apartheid. These people are all obviously brilliant. But I find more practicality in assuming that I am not.

I prefer to follow the sentence, 'We can't control the hands we're dealt,' with, 'And it's really hard to control how we respond.' I might even add a clunky footnote: 'But it's not impossible and it's made way easier if the other parts of your life are going good, like exercise and sleep and stuff, and also if you can find a way to make the whole thing meaningful!'

To deal with the unexpected, we want to make ourselves less explosive. We don't know what we'll be hit with, but we know who it will hit: your self. If you had a wasteland covered in dry twigs and gasoline, you wouldn't try to control the weather. You'd make the land less flammable. As for yourself, you'd work on the things you can control in order to soften the slings of the things you can't.

We also want to remind ourselves where the story ends. The meaning we attribute to a setback can be the thing that makes or breaks us. If we treat obstacles as the final page of a story, as though bad news hallmarks the end of an era, we make recovery a whole lot harder. If instead we see these painful moments as inflection points, falling in the middle of one of life's many eras, then recovery is the triumphant third act.

It might just take a bit of work to get there.

THE ART OF PREMEDITATIVE FIREFIGHTING

In part, this book is about self-improvement, which feels like a very unoriginal thing to write a book about. If you fall too deep down the rabbit hole of online diatribe, you might learn that some people think self-work is selfish, or that

trying to be better is ideologically flawed, or that thinking about anything other than [current issue] makes you worse than Hitler.

Maybe ... but nah. Self-work is a timeless human right, and one that is more important now than ever. Our first task is validation. I want you to feel like you deserve personal growth, because if you don't then the rest of the book is meaningless – not to mention the rest of your life.

Hearing about the promised land of self-improvement often evokes three responses. The first is the voice of possibility: it wants in. The second is your inner sceptic, who'll be assuming the whole thing is a cult/grift/multi-level marketing scheme until proven otherwise. And the third is your sorrow, that believes the promise will work – but only for other people. 'Easy for you to say,' it sighs, arming itself with excuses as to why you can't change.

These excuses form part of the call of self-destruction: the opposite of creativity. Unfortunately for you, the case it puts forward against your growth is pretty damn compelling. Instead of hitting you with generic worries, self-destruction hits you with a highly specific showreel of all your worst memories.

The feeling that you deserve a better life can find itself at odds with your personal history. We've all heard nasty things we can't forget. We've all got unhealthy stories we tell ourselves about what we can and can't do. We've all got loose screws, skeletons, secrets and regrets.

But we also all have things we're proud of, even if we can't see them all the time. There is treasure in your mind if you ask the right questions. Do you remember the feeling of freedom when you first rode a bike? Can you bring to mind memories of uncontrollable fits of laughter, shared with a friend who you're basically telepathic with? Can you remind yourself that you're doing pretty good, actually? Life gets sad and exhausting and all those things, but you're still here! Your spirit, like a strengthened immune system, is so committed to you winning that it's got you holding a damn self-help book! You've pushed through so many times and you'll do it again.

RAISING HELL

1. Think about your life in 5 to 10 categories, e.g. family, money, fitness, work.

2. Reflecting on the past few months, give each category a rating out of 10 (10 being the highest, 0 being the lowest).

3. Now ask yourself for each category: why didn't you score it one number lower? If you wrote 2/10 for money, ask, 'Why didn't I write 1/10?' If you have a 5/10 for fitness, why wasn't it a 4? In what ways could things be worse, and how have you personally prevented that from happening?

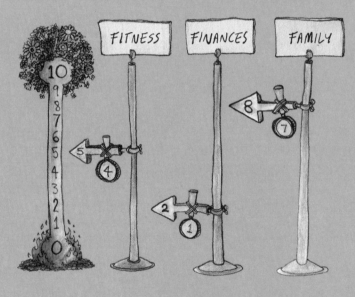

What we're doing is making the case for ourselves. By seeing Doom and Bloom as a spectrum, and not a binary, you remind yourself that the journey is possible, each tiny step is meaningful, and - despite your inner critic's insane ramblings - you're not a total sack of shit.

If you're feeling like a bit of extra credit, the next step in this exercise is to ask yourself 'what would one number higher look like?' Instead of falling into the all-or-nothing trap, we're getting familiar with the achievable next level of life we can actually hit.

CHAPTER 3

OXYGEN (YOUR ATTENTION)

When I was twenty-one, I used the money I had made selling ecstasy to travel South America. Edgy. In Bolivia, I found myself – as many young tourists do – on a mountain bike at the top of 'The Most Dangerous Road in the World'. True to its name, this road was a 64-kilometre stretch of slippery gravel often no wider than a small car on the side of a 200-metre sheer vertical drop-off. There was no guard rail. And the area was prone to landslides.

The guy we hired bikes from gave us a safety warning. 'These are baby heads,' he said, holding up a rock the size of a grapefruit. 'If you hit one of these with your wheel, you could come off your bike and fly off the cliff. If you don't want to hit a baby head, don't look at the baby head. Instead, concentrate on the clearer bit of road next to it. Focus on the path where you want to go and your body will naturally steer the bike there.'

It's a non-fiction cliché to derive meaning from an anecdote like this, but watch me do it anyway. In the advice meant for mountain biking, we find advice for life: whatever you focus on is the path you'll take. Focus on the obstacle and you'll hit it; look at the clear path and you'll take it.

But there's a second supposition we can see with bikes and baby heads. Attention is a matter of life and death.

At any given moment, it's estimated that your brain is processing around 11 million bits of information, but no more than 40 of them are registered by your conscious attention. This means that millions of things are *not* in focus, which leaves a lot of room for two people, side by side, to have completely different realities. One person could be taking in the rain, the lo-fi beats and the purr of the cat they're cuddling, while the other could be anxiously obsessing over the headline 'Your house will be nuked next: here's why'. One reality is relaxed and the other is ending this afternoon.

Even if these two people unite in their contexts, what they've been focussing on still has an echo.

Let's say these two people had to work together. The relaxed person might have a slow start, reluctant to leave their vibe, but ultimately their slower pace grants them clarity. The future-nuke victim, however, is beset with nihilism and anxiety. Why work if we're all gonna die? They are trying to process an attention hangover: their new context is weighed down by the previous one. These moments then have their own knock-on effect, and so on and so forth.

Currently, attention is seen as a resource. It's something you have and can use. But given that what you give your attention to determines every aspect of your life, it's worth asking: what even *is* attention?

EVERYONE KNOWS WHAT ATTENTION IS

In our illustrated journey from Doom to Bloom, we're currently highly flammable. Oxygen, famously, is what we need to stay alive, but it also keeps fire alive. So the thing that makes oxygen good or bad is the context. For this reason – and more, as we'll soon see – oxygen represents your attention in this analogy.

The phrases 'attention theft', 'attention economy' and 'competing for attention' are used constantly to describe the world we live in. This is the noisiest time humanity has ever known.

On an economic level, where individual attention is a prerequisite to making a sale, all this noise is both an obstacle and an opportunity. Getting someone's attention is a challenge, which means doing so becomes highly lucrative. Individual attention is treated as an itemised asset on which to build a business, as though it were wheat or iron. But should it be?

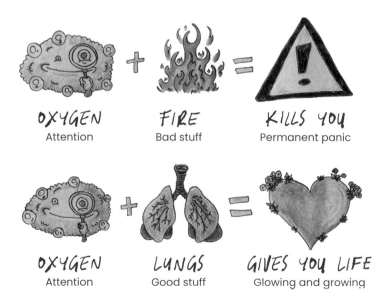

OXYGEN
Attention

FIRE
Bad stuff

KILLS YOU
Permanent panic

OXYGEN
Attention

LUNGS
Good stuff

GIVES YOU LIFE
Glowing and growing

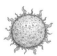

When you give something your attention, what exactly are you giving it? What are you giving these words right now? What is it that notifications are trying to steal? And what's so special about attention that it can form its own economy?

Attention seems to be something you have some, but not total, control over. And so, like oxygen in a wildfire, there's no shortage of contexts where your attention can be used against you.

Since billion-dollar industries are built on it, the word 'attention' is worth taking a minute to define. The obvious solution is to google it – which, of course, turns up dozens of competing definitions. What it is they're competing for, it's hard to say.

This problem was best captured by William James in his 1890 smash hit *The Principles of Psychology*: 'Everyone knows what attention is.' While James had more to say, describing attention as a form of conscious focus, it's this opening line that caught the world's attention. The blunt assumption became a famous one-liner because it somehow manages to simultaneously be so obviously right and so clearly wrong.

We should 'Stop paying attention to "attention",' writes researcher Britt Anderson in a 2021 article of the same name, claiming that as far as psychology is concerned, 'there's no such thing as attention'. I'm inclined to agree. The word is useful in conversation but murky in formal application. Not just in psychology, but in the world of business. In a market that reportedly trades on 'attention' as a resource, it is suspiciously convenient that 'everyone knows what attention is'.

The Stoics of the internet age have a go-to rule for getting perspective: when in doubt, ask an old dead Greek dude. In the frighteningly relevant words of Epictetus, 'You become what you give your attention to.' Attention is not a thing you have but a thing you *are*.

In social media terms, 'attention' is nothing more than a euphemism for 'life'. What you focus on, what fills your head, what occupies your thoughts, what uses your hours, what you do: this is your life. It is perhaps the most dangerous euphemism of the twenty-first century.

When we talk about attention theft, we're talking about life theft. When we talk about the attention economy, we're talking about the life economy. And all the internet noise competing for your attention is competing for your life.

BROADCAST PTSD

You might be asking: does a lawless media landscape rallying for attention *really* affect me? Sure, it might be annoying, but how much damage can all this screen time actually do? You might be scrolling deep into the world of your phone, but you're doing this on your comfy couch. For all the Doom you come across, if you see it from the safety of your living room you're probably pretty safe. Or are you?

When the Boston Marathon was bombed in 2013, the United States suffered their first major terror attack since September 11, 2001. While the physical attack was confined to Boston, television screens and newsfeeds filled up with distressing footage, spreading the trauma. Back in 9/11, a group of researchers – Dana Rose Garfin, E Alison Holman and Roxanne Cohen Silver– had asked a simple question: if you didn't physically witness the attacks, could media exposure still cause you psychological distress? The Boston bombing allowed them to answer this question: yes.

In 2002, the researchers had concluded that 'the psychological effects of a major national trauma are not limited to those who experience it directly'. As for what determined the trauma's severity, the coping strategies a person used were critical. Someone who had seen the attacks on TV could experience more psychological distress than someone who witnessed them in person, as the person watching a screen is far less likely to employ a coping mechanism than an eyewitness.

Twelve years later, the researchers found that those who had directly witnessed the bombing showed tremendous emotional resilience. While these people had experienced a terror attack firsthand, they had also seen their city rally together to respond to it. Instead, high-acute stress was most prevalent in the people who had six or more hours of daily media exposure in the week following the

bombing. Heavy media exposure was nine times more likely to traumatise its audience than direct exposure to the attack itself.

Given that media saturation has only increased since 2013, it's natural to feel a little uneasy about the world we're walking into. While I don't suggest that we fill in the unknowns with fear, I don't think we should fill them in with sunshine and rainbows either.

Trauma can be inadvertently deployed at scale, as if it were a digitally spread disease. But, crucially, not everyone exposed to it gets sick. Like a pathogen, this Doom will have an easier time infecting you if your mental immune system is already working overtime. If your personal life has you fighting demons akimbo, dumping an additional dollop of distressing news into your brain is unlikely to help.

But how do you start? What is a practical way to get better at controlling your attention? What is something small you can practise to make you better in the moment? Athletes have drills, singers have scales, and workplace bullies have Yelp reviews. As for training your attention, consider doing … nothing.

A few minutes of doing absolutely nothing, being unstimulated, undistracted and even bored, works wonders over time. And in a world where switching off is borderline antiestablishment, to pause is to say your attention is not for sale. In these moments your life isn't commodified, fought for, or fracked. It's all yours.

HANDLE THE CANDLE

AN EXERCISE IN OXYGEN AND ATTENTION

1. Light a candle, and put a timer on for at least two minutes.

2. Breathe in through your nose and out through your mouth, exhaling at the flame slowly and gently to make it flicker but never die. See how much you can make the flame dance without blowing it out.

The idea is that we focus our attention on a game. A scattered mind and shallow breaths lead to stress, but when we Handle the Candle we are opting to be unstimulated and focused. Meanwhile, the slow, controlled, deep breaths work their magic. Time slows down and you feel yourself relax.

CHAPTER 4

HEAT
(YOUR CONTEXT)

We've all heard that phrase, 'You're the average of the five people you spend the most time with.' The idea isn't perfect – by this logic, I'm one-fifth toddler – but it's a useful way to understand culture. A set of people shape each other's ideas, behaviours and actions, and a culture is born.

Cultures can be found on every scale. You can see them in families, nations, schools, workplaces, Renaissance fairs, circus troupes, crypto bros, dance mums, goths, pyramid schemes, K-Pop stans, UFO chasers, cheerleaders, flat-earthers and drum circles. You might find yourself traversing ten different cultures in any given day.

Not every culture is great. Some cultures encourage you to be better while others are more likely to bring you down. Some cultures are so cynical and poisonous that they tank your worldview without your permission. They fill you with Doom. We're calling this a Doom culture.

A toxic workplace is a textbook Doom culture. You spend your time there (thanks to that pesky reality of money), and in doing so you absorb its yucky customs. In our mission to grow a garden in hell, this Doom culture is the heat in our fire triangle, bringing us to the edge of burnout at any point.

To wrap our heads around it all, let's explore a specific example of a Doom culture that has a hold on all of us: the Doom culture that sits in our pockets ...

MOORE NOYCE

Before Intel was called Intel, its founders briefly thought about naming their fledgling company after themselves. But Gordon Moore and Robert Noyce realised that calling a computer company 'Moore Noyce' was dangerous territory. As computers became mainstream, they knew that their technology would – if nothing else – make a lot More Noise. This wasn't their only accurate prediction.

In 1965, *Electronics* magazine asked the budding computer engineer Gordon Moore what he thought the next ten years would bring for his field. He had noticed that the number of components in an integrated circuit had been doubling every year, increasing processing power and decreasing cost. Essentially, Moore said computers would get heaps better and way cheaper, real fast. Moore suggested this trend would keep going all the way to 1975: he was uncannily accurate. From 1975, he figured processing power would double every two years, until circuit components hit the physical natural limit in the mid-2020s. This prediction was in the ballpark too.

Compare this breakneck speed of technological progress with the leisurely pace of our biology. Evolutionary psychologists say the last update our brain received was the development of the prefrontal cortex about 250,000 years

ago. Our brain's chances of catching up to the pace of technological change are grim. Can the gap be closed with performance-enhancing neural implants, genome editing or school spirit? Time will tell

When it comes to how we fit into this schism, our era's technological changes – as with almost any inventions – are brilliant in some ways, and terrifying in others.

Modern technology has saved countless lives and transformed our working world. Many of us have found meaning and connection through global online networks, or personal freedom and mastery through

the internet. And having the world's information at your fingertips is heaven to optimistic entrepreneurs.

But it has also brought us screen addictions, mental-health erosions from intrusive content, empty wallets from predatory e-commerce tactics, worldviews rotted by clickbait, and general demoralisation about the sheer volume of unsubstantiated opinions circulating as 'fact'.

Questioning the way we use the internet can sometimes be dismissed as the new 'Elvis shaking his hips'. The only difference is that the teenagers of the 1950s weren't watching Elvis's hips for seven hours a day. And when seven hours makes up nearly half of a human's waking life, dismissing the internet so quickly seems unwise.

THE BEST THING SINCE SLICED MONEY

While the pace of the online machine is at odds with our nature, much of its success stems from its calculated compatibility *with* our nature. Consider the metrics of social media: likes, follows, shares, and where you rank in someone's Top 8 on Myspace (rest in peace). When it comes to quantifying aspects of life, social media might be the biggest change we've had since the invention of money.

The idea of things having value was not invented by money. Before shell currency, a farmer still knew that 'some chickens' was better than 'no chickens'. But money made value a visible metric. The more visible a metric, the more likely we are to chase it. Invisible metrics, like happiness, self-respect or the quality of your relationships, have a harder time getting our attention.

Similarly, social media didn't invent our social nature. Wanting to be accepted, liked and listened to are fundamental human motivations. But social media has given it numbers. This has done to social status what money did to value. As mental clarity is still yet to be quantified, we're more likely to optimise for numbers on a screen.

Tragically, this dystopian ranking system was set into hyperdrive by a guy trying to do the opposite. Facebook's 'like' button entered the world in 2009 as a project led by Justin Rosenstein, who designed the feature with pure intentions. He wanted to 'make positivity the path of least resistance'. He *was* trying to game our psychology, but not in the way the 'like' button would later be accused of doing. Rosenstein hoped seeing the big thumbs up would 'bias people more towards structuring their communication around positivity'. Instead, the world got busy structuring communication around getting the most 'likes'.

The tech companies took to their newfound power the way a dog takes to chocolate. In an interview for the 2020

documentary *The Social Dilemma*, Rosenstein said that, due to our unregulated economy and 'short-term thinking based on this religion of profit at all costs', we now 'live in a world in which a tree is worth more, financially, dead than alive'. He pointed out that we need to wake up a realise that we *are* the tree, and so we can't just sit by and watch.

To make an omelette, you have to break a few eggs. And to make the world's most profitable omelette business, you have to break people down until they're hopelessly addicted to omelettes, never more than three feet away from an omelette, invested in a system built on widespread omelette addiction, financially reliant on the growth of the omelette industry, and prepared to give their one and only life to eating omelettes.

While the 'like' button was busy unintentionally gaming our psychology, other features of social media were less subtle in their appropriation of Psych 101. Facebook's first president, Sean Parker, said in a 2017 interview that the site's building process was guided by the question, 'How do we consume as much of your time and conscious attention as possible?' Parker added, 'It's a social-validation feedback loop … exactly the kind of thing that a hacker like myself would come up with, because you're exploiting a vulnerability in human psychology.'

Exploiting human nature to maximise use-time might have been a winning strategy for building Facebook, but it's a far cry from building a better world.

As more content began to flood the platforms, a new problem arose. When there are too many posts for one person to see, a chronological feed can lead to some users missing out on gold, and other users being bored by spam. Enter algorithmic ranking! The new strategy was to show people the content that kept them engaged.

As the platforms began to push compulsive use to its logical extreme, the north star of social media morphed from 'likes' to 'engagement'.

If likes had become a yardstick against which you could measure your value as a person, engagement became synonymous with racking up comments – and *nothing* does this as well as hot-button issues.

THE GREAT FLAME WAR

Imagine two fires wrestling.
Confused yet?

What doesn't work about this image is that as soon as two flames meet, they converge into one big inferno. When two people, both on the verge of combustion, clash, we see something similar. Instead of existing as two separate fires wrestling, to the outside observer they become one gigantic flame war.

This one gigantic flame war and the smoke it produces are key to understanding any Doom Culture. When people around you fight and complain, you inhale their second-hand-smoke. For the particular Doom culture of the internet, the flame war represents the tribalistic culture wars we've all seen ad nauseam. Like spats in a family, a bully on a bus, or a punch-on at a party, when we witness conflict we suffer underneath its thick, unbreathable smoke.

While you personally might feel unaffected by the trappings of the terminally online, the world you inhabit isn't. In the language of our Doom-to-Bloom arc, you might not be on fire, but plenty of people are and their smoke is making it hard to breathe. And in the language of my inner twelve-year-old, we're all in this swimming pool together, and if millions of people are peeing in it, then we've all got a problem.

As the internet matured, it morphed into the ideal battleground for clashing ideologies. The less considered an argument, the more traction it got. These fights are fought in unforgiving language that often seeks to bolster the author more than educate the reader.

Nuance is not the first language of the internet. It's more common to see a tantrum than it is to see a measured exchange. Such vitriol is often a byproduct of the desire for simplicity. The desire to see the world in terms of 'good guys' and 'bad guys' is the gateway drug to a rigid all-or-nothing belief system. At best, this makes for a life lived in personal turmoil. At worst, it creates a thought culture that strips individuals of their independence, priming them for manipulation from some terribly bad actors.

So what makes our fetishisation of simplicity so hellish in the digital age?

In the age of disinformation, misinformation and malinformation, many people lack faith in reality. It's not necessarily all their fault: government institutions, overnight experts and partisan media outlets have done a questionable job at building trust in recent years. Fringe groups have found themselves bullied. The term 'conspiracy theorist' is considered a pejorative label, as opposed to being a person with an unproven theory about a conspiracy. Even the idea of 'seeking the truth' has become a meme.

Is it any surprise that ideologically marginalised people form alliances? Perhaps the real heretics are not those who believe 'alternative facts' but the people who ridicule them as if they were one-dimensional punching bags instead of treating them like humans.

I've been both types of people in the past. I've had wrong information and I've dunked on people for having wrong information. I was not immune to the combative culture of the internet. What I regret most is not the sharing of misinformation but the shaming of it.

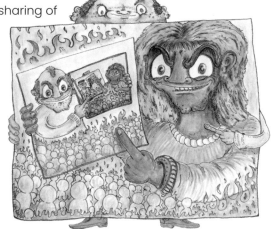

The Doom comes from people *knowingly* spreading disinformation. People who unknowingly receive false facts and feel compelled to share them are victims. To treat them with conflict, not compassion, is to fall into the trap. When bullied, the disinformation victims simply find other believers and form an echo chamber. When bullying, the

debunkers do the same, blindly becoming the other type of victim produced from the same crime.

The clash is how the disinformation spreaders win. The aim isn't to obfuscate the truth but to make normal people hate each other for otherwise trivial things.

Perhaps the saddest reality of this tribalistic flame war is how poorly its soldiers represent society. In a study on X (fka Twitter), Pew Research found that 92 per cent of the platform's posts were made by 10 per cent of its users.

If a loud minority is constantly learning that the way to be heard is through vitriolic group dynamics, then it doesn't take long until every topic looks like a minefield.

It's hard not to stare at a car crash. The worse it is, the more you want to look. Insane online opinions have a similar siren song. Maybe you get caught on murder, injustice, privilege, slander, war, or all of the above. But when we accidentally get caught in the omnipresent crossfire, lured by a hot take, we're invariably drained to exhaustion.

While this type of tension is at its least subtle online, it's found everywhere. From dysfunctional group projects and weird extended family members, all the way up to corrupt governments and media personalities. When angry people fight, those around them inhale their second-hand smoke.

Even Dante Alighieri was disappointed by pathological drama-starters. His response? Remind the world that 'Sowers of Discord' belong in the eighth circle of Hell.

SUFFOCATING IN THE SMOKE

How many opinions can you hold in your head? The right answer to that question varies from person to person, but the wrong answer applies to everyone: the amount the internet delivers.

It's too much, man.

We've all consumed a steady diet of clickbait news, infographics, vapid cringe, hype, reaction videos, group chats, memes and more. It all goes in, but then what? What does your head do? It does its best to make sense of it at all, but at some point it's just exhausting. Whatever happened to going for a nice sunset walk and talking about your favourite plants?

The second-hand smoke we're choking on isn't just information overload; it's opinion overload. You likely ingested so many opinions in the past few years, and you likely felt you had to somehow synthesise all of them, spit out your own opinion, and pray to god no one yelled at you for being wrong.

The problem with opinions is that they're not all created equal. Some people are more informed on particular subjects, so their opinions are more useful. But the internet has a way of extracting useless opinions and sticking them in front of you as though they were somehow important.

The result: your head becomes like a plastic shopping bag trying to hold twenty bottles of undrinkable expired milk. It splits at the side, breaking under the weight. Cue: fatigue, depression, anxiety, guilt, invalidation and generally tapping out.

Most of us have good intentions. Most people want a better world, but after reading so many opinions on the best way to build it, most people's heads explode.

Let's say you want to do something about the climate crisis. Within just an hour, you could read a handful of threads and 'learn' the following:

* Help starts with you!
* The only people who can really make a difference are oil company CEOs.
* You should go vegan.
* Going vegan is the ultimate form of privilege.
* The best way to help save the planet is to eliminate all humans, starting with yourself (thanks, 8chan).
* What about the rising tensions in [insert country here]? Prioritising the environment is problematic.
* Donate money!
* Donating money is problematic.

It breaks your brain, and broken people can't save the world.
So what do you do?
The trick to avoiding opinion overload lies in how well you can define a problem. Instead of suffocating in someone else's smog, establish boundaries the way Voltaire did: 'If you wish to converse with me, define your terms.'

DEFINING DOOM

A problem well defined is a problem half solved.

FUEL

How are you feeling right now, in this exact moment?
What things have you been lugging around recently?

OXYGEN

What things do you love giving attention to?
What hijacks your attention away from these things?

HEAT

What are some cultures, big and small, that you interact with? E.g. friends, family, sports teams, groupchats.

SPARK

What things, out of your control, tend to set you off?
What surprises make you happy?

ICE

Where in your life are you stuck? Where in your life do you have momentum?

THAW THE FROZEN CORE
(YOUR MOMENTUM)

Since Dante's voyage through Hell serves as an inspiring precedent for our own, it's worth noting how *he* dealt with Doom. As Dante the character finishes the 'Inferno' leg of his odyssey and Dante the poet unofficially sets the Renaissance in motion, we find what lies at the heart of Hell.

I hate to spoil an ending, but the poem's been out for 700 years so I don't feel too bad about this one: Dante and Virgil (the ancient Roman poet that Dante fan-casted to lead him through his fictional 'Inferno'), having traversed eight zany circles of Satanic torture, finally arrive at the famous ninth circle of Hell! Except, instead of fire and brimstone, Hell's ultimate circle is frozen over with ice. Dante felt that scorching flames were too good for this circle's victims, those who committed treachery. These are the backstabbers who crossed people who loved them, including: literal backstabbing icon Brutus; Cain, of Abel-killing fame; the Trojan elder Anetor, who was rumoured to have let in that harmless wooden horse; and Judas 'The Jesus Killer' Iscariot.

But when it comes to our modern-day Doom culture, and feeling stuck in personal hell, I want to focus on a different kind of treachery …

The worst trick Doom culture pulls is that it makes us traitors against ourselves.

Your phone is an engineering marvel: a result of humanity's best and brightest coming together in global collaboration to serve the whims of profiteering technocrats who see more value in keeping you addicted to their products than in helping you. If you aren't winning that war, it's not your fault! But while you're the victim in this story, you also have to be the hero. Phones aren't changing any time soon, so that part has gotta come from you.

SATAN IN ICE

Before we get stuck into some Groundwork, let's wrap things up with our favourite graduate of Hell, Dante Alighieri. As 'Inferno' hits its cliff-hanging conclusion, Dante and Virgil finally reach the centre of Hell. And in case you're wondering, it still looks like a blizzard. Hell's very centre is frozen and Satan is encased, up to his waist, in solid ice.

Curiously, Dante's Satan isn't particularly powerful. He's actually pretty pathetic. He spends his time chewing on traitors like Judas, not being allowed to talk, and getting punished as though he's just another sinner. Unlike your standard cartoonishly evil devil, Dante's Satan is completely void of personality. Interacting with people, feeling people's presence and even seeing light are all privileges he's denied. He is something to be pitied. The deepest suffering one can be dealt is being stuck in eternal isolation.

DON'T FREEZE

It's one thing to say 'stare at Doom', but it's another to actually do it. So let's break it down into an ice bit of imagery.

Imagine that your various anxieties, mental blocks and limiting beliefs are frozen blocks of ice. These things keep us stuck in life, feeling like we are encased in a glacier, so of course we avoid them. Looking at them can be incredibly painful. But in the long run, the real pain comes from *not* looking.

What we avoid is different for everyone. You might avoid looking at some blunt feedback, medical results, or your junk draw. Perhaps you're delaying a job resignation, a break-up, a big move, a minimalist purge of all your possessions, feeling grief, brushing your teeth, skydiving, paying your taxes, responding to an oil light, joining a gym, starting a novel or finally dealing with your floordrobe.

When a mouse growls like a lion, it's safer to assume it's the latter. But when we look at it and see that it's just a mouse, we can start to relax our shoulders, unclench our jaw and understand that we're not in the danger we thought we were in. Like the Wizard of Oz, or Dante's Satan, Doom is gigantic behind the curtain and pathetic when examined. The first step is to simply acknowledge that Doom's bark is infinitely bigger than its bite.

In our fiery metaphor, our aim is to reduce the conditions that produce flame wars and burnout. We've seen how the fuel of Doom culture is everywhere, waiting to be set alight; how the oxygen of our attention is a gamified commodity; and the way our feelings – like fuel – complete the equation. We improve our odds of not burning to a crisp by addressing any one of these elements.

Our personal lives might be stressful, but this is far from set in stone. Over the next few chapters, we'll be treating all the shit you've been dealt in life the way farmers treat all the shit they're dealt from their livestock. Instead of letting the shit fester and turn their property into a gross uninhabitable cesspit, farmers turn it into fertiliser and the land becomes lush.

THE BLANK PAGE

It's easy to see why we procrastinate. When we're on autopilot, most of us default to a simple algorithm: pick the option that conserves the most energy. Do tho laundry or do nothing? Nothing uses less energy. Read a book or check my phone? The phone feels way easier (good on you for suppressing that one).

Starting things is hard – and doing hard things is unnatural. We can all conjure up the image of the author staring at her typewriter (she's going through a steampunk phase, just let her have it) with a blank papyrus page staring straight back. Her tortured brain oscillates between frozen and self-flagellation. The blank page is perfect. The unbroken silence is easy. To taint these things with our wonky words is to make them worse. The irony here is obvious: we can't have the bright future without a messy present.

Procrastination is often talked about as a root problem. 'If I could stop procrastinating, everything would fall into place.' This is like talking about the dreaded flashing oil light in a car as a root problem. 'If I could just stop that light flashing, the car would be fine.' With a car, we know that the real problem is that it needs oil. If you only addressed the warning light itself, and smashed the little bulb to stop its incessant blinking, the car's function would continue to decline. If you only address procrastination, and not the root causes it's coming from, you'll also find yourself broken down on the middle of the highway.

Procrastination is a symptom with very real consequences, and to fix symptoms alone is to bandage up a bullet wound while gun violence goes unchecked. To solve the root cause alone is also only half the job. For best results, we're going to get into the Groundwork.

THAW'T EXPERIMENT

1. Start by identifying 5–10 blocks in your life, big or small. Draw them as labelled ice cubes. What are you procrastinating on? Where do you feel resistance?

2. What is the opportunity cost of avoiding these problems? For example, you might be postponing a tough conversation so you don't have to feel the stress of having it. Meanwhile the stress of putting it off, while less intense, lasts far longer. It finds its way into your brain just before you nod off to sleep. This is an opportunity cost of keeping that ice block frozen.

3. What are the hidden benefits of dealing with these problems? Just as a melted ice cube can extinguish a fire, what new opportunities does a solved problem present?

 If you're putting pen to paper, write these down as potential actions you can take to move forward in that area of your life. If opening a notebook isn't on your agenda at the moment, then treat the above as a Thaw't Experiment.

A BIG DECISION

A SOMEDAY PROJECT

A TOUGH CONVERSATION

A TOMORROW TASK

GROUND WORK

A SEED DOESN'T GROW IN A FIERY PIT or a raging flood. And it doesn't grow just because you really want it to. It needs to be planted in soil.

Soil can't be replaced by willpower, positive thinking, screaming, bullying, telling the seed it doesn't want to become a tree badly enough, accusations of laziness, or showing the seed inspiring pictures of the type of tree it could one day become.

Think of a new idea as a seed. It could Bloom into the plant it was destined to be, but without the right Groundwork, it'll stay a seed.

In our creative lives, turning ideas into reality is the whole shtick. One of the reasons creativity is such a rewarding lifelong pursuit is that most ideas are stubborn. Getting them to Bloom is unpredictable, which is both delightful and frustrating.

The seed has potential. But as anyone who has ever received a backhanded compliment on a school report will know, 'potential' doesn't guarantee anything.

The seed might become a tree, but it also might not. Why not? It's almost never because the seed is defective. Seed autopsies aren't really a thing, but if they were, they'd point to the place and the way the seed was planted, the weather, and how the garden was tended. Some coroner's reports might even find that the seed's cause of death was: 'I was going to get round to planting that eventually.'

Similarly, not all ideas blossom into greatness. In fact, most don't. But the ones that do almost never happen by accident. There is a process that takes them from nothing to something, and – broadly speaking – these processes reveal patterns we can use in our own life.

Curiously, many of those processes – like the seed in the garden – begin long before a project does and in unrelated domains. An exercise routine impacts a creative idea the way good soil impacts a tomato seed. The stronger the foundation, the better things grow.

In horticulture, Groundwork is literally working on the ground. It's the least visually exciting part of

the job but it's also what differentiates a beautiful garden from weeds. Get the Groundwork right and everything else follows.

In this section of the book, we'll be focusing on everything that isn't directly part of our creative practice but that helps make it possible. We'll be treating the components of our lives not in isolation but as a complete system in which everything affects everything else. The mission is to make sure we're not making our creative practice any harder than it needs to be.

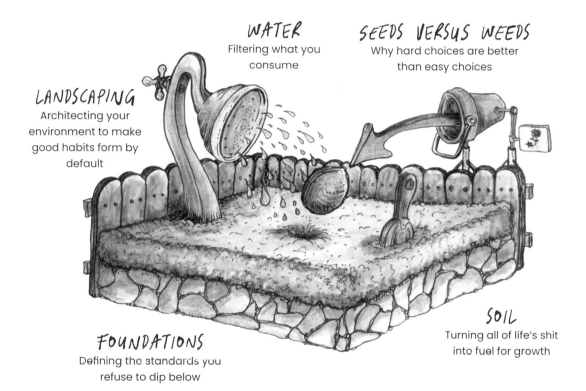

WATER
Filtering what you consume

SEEDS VERSUS WEEDS
Why hard choices are better than easy choices

LANDSCAPING
Architecting your environment to make good habits form by default

SOIL
Turning all of life's shit into fuel for growth

FOUNDATIONS
Defining the standards you refuse to dip below

CHAPTER 6

FOUNDATIONS
(SET YOUR STANDARDS)

One of the biggest blocks to creativity is the daily grind of life. Immersing yourself in the creative state takes time. This means it's up against everything else that takes time, like work, family and sleep. And when work makes you money and money stops you from dying, ceramics and short stories don't stand a chance.

The problem isn't necessarily solved by incorporating a creative practice into your schedule. Just because you squeeze in ten minutes to let your mind wander while you play the accordian doesn't mean your mind will wander as freely as you want it to. Instead, it's more common to feel a sense of guilt for not working on more important problems. And should you get lost in the moment, you might find you've not just delayed solving other problems, but your deferral created new ones. The next time you consider indulging in a craft, you think, 'I'd love to take some time off, but if I do that the problems will get worse and I'll have even more stress!'

All of this adds to our sense of impending Doom.

This is tough because there is some truth to the feeling. It would be lovely to just chill out on a beach for a year and write sonnets, but life is expensive and there's a real stigma against robbing a bank. There are ongoing responsibilities

that aren't up for negotiation: kids, debts, contracts, promises, and feeding your six cats. These things are all directly impacted by you giving your time to creativity, and those impacts create even bigger impacts, and the whole thing spirals out of control until everything explodes.

This feeling is learnt from a lifetime of experience: times when you dropped the ball and stresses multiplied as a result have taught you the importance of not dropping the ball in the first place. Mostly, this knowledge is useful, but – as is the case with Vegemite, face tattoos and those six cats of yours – add too much and it becomes a problem.

Some people argue that a small amount of impending Doom can be motivating. Sometimes pressure makes diamonds. But too much pressure and the diamonds turn to dust.

We're told to shoot for the moon more than we're told to build a floor from which to shoot. We're made to believe that goals of grandeur are necessary and safety nets optional. The result is, we feel like we're treading water just to stay alive. And as we're going to see, this is about as grim as feelings get

CURT AND THE RATS

Are you ready for some hijinks involving a scientist and a rodent? Full disclosure: this is basically a story about a guy in the 1950s killing a bunch of rats. However, the results of this scientific true crime are too compelling to ignore.

The scientist, Curt Richter, threw a bunch of rats in a tall beaker of water. The rats, eager to survive, began to tread water, but they figured out quickly that they were surrounded by glass walls. They were treading indefinitely with no way to escape. If they stopped swimming they'd die, but if they kept swimming it still seemed like they'd die … just later. So they all died. They treaded water for about five to ten minutes, did their best impression of Jack from *Titanic*, and died in Curt's pursuit for knowledge.

If that wasn't enough, Curt then set about drowning a second set of rats. The new gang began treading water too, but before they met their death, Curt reached into the beaker and saved them. He let them get nice and dry, and then threw them back into the water – multiple times. With the rats back in the water for a final time, Curt began his next experiment. When the clock ticked past that ominous ten-minute mark, these rats did not die. Instead, with fresh memories of being rescued, they kept treading water for an average of sixty hours! And then they died.

Curt believed the thing that separated the ten-minute rats from the sixty-hour rats was hope. The first rats gave up because they believed there was no way out. But the second rats knew the situation was not hopeless – they'd been rescued before – so they hung in there.

It's a bittersweet story. The sweetness is that simply believing we're not doomed is a ridiculously potent source of motivation. The bitterness is that the

resilient rats did eventually drown too. The experiment is clearly a testament to the power of hope, but the story itself is testament to nihilism. What actually happened in Curt's lab was bleak, and what those rats actually learnt was, 'Try and hope all you want, you're still going to die.'

Curt's 'Hope Experiment' is a classic experiment turned self-help parable. It quantifies hope as something that increases your will to live by 3600 per cent, and a new telling of it resurfaces on the internet every six months or so. But whenever it does the rounds on Reddit, X or LinkedIn, it seems like we're meant to ignore the fact that the resilient rats still drowned. Censoring their deaths keeps us from a valuable insight: if the first lesson is that hope can dramatically improve your life, the second lesson is that hope alone is not enough.

TREADING WATER

Before you can get started creating, you need a floor to stand on. While your inner world is no longer a fire hazard, we've run into a different problem. Staring at all those frozen hunks of Doom has led to far more water than we need.

While confronting our anxieties is necessary, it's also pretty scary. You might've been avoiding checking your bank balance because you're terrified you'll see a number you don't like. The longer you left it, the more intimidating it felt and the more frozen you became. When you break the cycle and look at how much money you have, you unfreeze yourself from ruminating about your bank balance, but not from the bank balance itself.

Your problem shifts from dreading reality to dealing with reality. And while this shift is what makes growth possible, it's also what makes growth mandatory.

In the allegory we've been crafting on rumours of a beautiful garden, our imaginary block of land, once moments from flames, suddenly looks like a flood.

Addressing your problems is better than fearing the shadows they cast, but it's still highly destabilising and it demands immediate attention. It can feel like you're treading water, like one of Curt's rats. You have no idea how long you'll be kicking or how far you'll sink if you stop.

Meanwhile, some yuppies in a yacht keep reminding you how motivating this must all feel: since you don't yet have a yacht, you have a yacht-getting-sized journey ahead of you!

For a split second you indulge in the idea that you could have a yacht. And then you realise that the best part of your daydream is not actually the fancy boat but the idea that you wouldn't have to tread water anymore. You're desperate for a floor so you can relax.

As we saw with Curt's rats, what won't work is hope alone. What you need is something that can keep you afloat and let your legs rest: perhaps a life buoy or an inflatable flamingo. It's no cruise ship, but it's a start.

The foundations of your inner world represent the essential parts of your life. These are the things that keep you stable and grounded. A simple way to define your foundations are to break them into categories. Feel free to add categories of your own.

* **RELATIONSHIPS:** Who is the (at least one) person who leaves you with more energy?

* **MONEY:** What is the minimum you need to earn to survive?

* **HEALTH:** How much do you need to move in order to live a good life? What is your level when it comes to what you put in your body?

* **PERSONAL HABITS:** Is there a line you won't cross when it comes to sleeping in? Have you sworn off alcohol, gambling and starting world wars? What is the standard you refuse to dip below?

Of course, it's not just the impending Doom of the ocean that makes the present hard to enjoy. It's also those damn yuppies on the yacht! Even if all you need to not die is an air mattress, the yacht yuppies will make you feel like it's not enough.

This is the second benefit of the foundations. They double as your definition of 'enough'. A to-do list is otherwise endless. If enough is undefined, relaxing is corrupted. Instead of enjoying the hammock, you feel guilty for wasting time. You oscillate between almost relaxing and almost working, doing a terrible job of both. Knowing your foundations allows rest to actually be restful.

When we really think about what constitutes 'enough' in life, we're met with a curious thought: what do I even need? We start to consider our bare minimum.

The bare minimum is the absolute least you need to do in life in order to make your life not go backwards. This isn't about striving for excellence, but about building a floor we can stand on. As our society becomes more obsessed with productivity for productivity's sake, the importance of defining your bare minimum gets lost. Without actively defining a safety net, it's easy to assume there is no safety net. If you make a mistake, you'll fall forever. So we try avoid mistakes, all the while feeling a sense of impending Doom.

Simply knowing that you're not Doomed can change your behaviour profoundly.

Some days, you'll be in the zone and you'll see yourself blitz right past the bare minimum and into the world of extra credit! Not only will it feel rewarding, as though you're doing your future self a favour, but it acts as a form of creative insurance. Simply knowing you've done more than you have to can be the difference between guilt and gratitude.

BARE MINIMUM OR KILLING IT

Big dreams are the first step to a big life – but they don't guarantee it. In fact, sometimes the opposite is true. Overly ambitious goals have a tendency to intimidate us out of ever chasing them. It's why we're often told to break those goals down into measurable, actionable, achievable steps (yes, I am mentioning SMART goals in a self-development book). But we don't want to lose sight of the gold medal, and some days we really do just need a participation award. That's why we need to make two to-do lists.

1. **The Bare-Minimum List:** List the least amount of stuff you need to do today (or this week, or this year) in order to make tomorrow (or next week, or next year) not worse. This list is especially handy when life hits you with a proverbial truck – when you're busy, sick, or the wifi is weird. If you struggle with the guilt of not doing enough, I can't recommend this list enough.

2. **The Killing-It List:** (I workshopped a few names that were less metal, but nothing had the same ring to it). This is a list of all the things you would like to get done, but can go un-done for another day. It shows its true power when you get in the flow, and makes sure you don't waste that feeling on deciding what to do next. You just do it.

This system harnesses you on your good days and your bad days. And it makes easy wins a gateway drug to big wins.

CHAPTER 7

LANDSCAPING
(ENGINEER YOUR ENVIRONMENT)

Your environment – be it a house, a van or an underground lair – has an enormous impact on you. By intentionally crafting our surroundings, we can naturally elicit our best selves. For instance, quitting beer is infinitely easier if there aren't any cold beers in your fridge, and quitting biting your nails is infinitely easier if you keep them in the toolshed.

During the Vietnam War, many North American soldiers became addicted to heroin. For some it was a coping mechanism, for others pain management or simply recreation. But curiously, when the soldiers returned home, 90 per cent of them kicked their habit. During the war, heroin was accessible and normalised among the forces. Upon returning to life in America, where heroin was not a staple, the habit lost its vice grip on the soldiers. The thing that broke one of the most notorious addictions was not discipline or willpower, but physical environment.

So how is your environment helping or hindering you?

OPTIMISE FOR LUCK

I loved drawing as a kid, but I stopped when I was twelve. I remember it was a Friday. I had filled a sketchbook with portraits and brought it to school with the sole purpose of showing them off to my art teacher. I wanted his praise but I got his indifference. He didn't like it or hate it; he nothing'd it. Being a twelve-year-old with a twelve-year-old brain, I concluded that I could not, should not, must not draw, and shame on me for thinking otherwise.

Roughly ten years later I started drawing again, but it wasn't one of those big epiphany moments you see in biopics. I was living in a dilapidated mansion with approximately four to ten people – and, crucially, four to ten people's *stuff*. One housemate was a brilliant artist and a terrible minimalist, so our rooms were full of canvases, pencils and paints.

This housemate and I had an unofficial morning ritual. We'd sit together in the sun and have rambling conversations over the course of a coffee. As we did this, he'd draw a small sketch and I'd practise whatever musical instrument I was obsessing over that week. On this particular day, I'd misplaced my mandolin (long story), so I drank my coffee empty handed. As I watched my friend drag ink across the page, I reflexively picked up a piece of paper and one of the hundreds of pens scattered on the floor and I began to draw.

I was bad. Terrible, really. But I felt my 'creative pursuit' was music, so I didn't need the pictures to be good. I just wanted to feel the pen glide across the paper. This was my way of apologising to the pen for locking it up for so long, and I'd like to think it accepted my amends.

My drawing hand soon became possessed, like an energetic dog finally outside after a long spell of rain. If you do most things long enough it's hard to stay terrible at them. I learnt that illustration works like most things, which is to say I unlearnt the idea that artistic potential is assigned at birth (exclusively to others).

My first sense that I was able to push my drawing skills came one day when I was copying my talented

housemate line for line. This was common, and encouraged, right up until it wasn't, which was today.

'Get your own style, man. Stop biting mine,' he snapped. He was one of the few snappy people I'd met who managed to be snappy in a good way. He had that specific neurotic charm found in people who need ten coffees to get through the day, ten projects to focus on at once, ten cones to get to sleep, and have no intention of changing. And here he was, snapping. He let me know – in his own snappy way – that I was improving. I had gone from amateur to potential threat.

All this illustration later turned into my career, but the craft itself re-entered my life seemingly by accident. Or did it?

My environment at the time, covered in art supplies, was conducive to this type of discovery. My routine, a daily collaborative, low-stakes creative practice, made this accident near inevitable. Much of life is up to chance, but your environment and your routine allow you to play the odds.

On the one hand, I got lucky. On the other, I had optimised for luck.

Designing your surroundings so they're conducive to your goals is what we'll call landscaping.

LANDSCAPING CHOICE

Landscaping is classically the process of shaping the garden to your liking, as though you were a divine sculptor. The purpose here is to make your local ecosystem lovely and naturally conducive to blooming.

Landscaping in this book is about using choice architecture to facilitate the lifestyle we want.

Consider the places where you spend most of your time. Maybe you're in one right now. How does your physical space facilitate the day you'd like to have? What parts of your surroundings make your goals harder than they need to be?

Choice architecture is the way options are presented to people to influence their responses. You often see it at play when you create an account for a service and the box that says 'send me marketing material (optional)' is pre-ticked. This default ticking, while tiny, has a dramatic impact.

For the business, it could be the difference between failure and success.

For the customer, it determines whether or not they'll get three pointless emails a week until long after they die.

The concept was popularised by economist Richard Thaler, who would go on to win the Nobel Prize, in large part for his work on decision-making. He discusses his ideas at length in his 2008 book *Nudge*. Given the book has been out for a while now and Thaler already has had plenty of kudos, I'm going to reference my mum instead.

Mum is a preschool teacher and she uses choice architecture to psychologically manipulate three-year-olds. If she wants her class to sit down, Mum will ask, 'Would you like to sit down fast or slooooooow?' The foolish children think they have a choice. They don't. My evil genius mum watches them sit down 'slooooooow' like brainwashed melting ice creams.

Mum has used a technique known as Hobson's choice. The idea is that the decision-maker feels empowered, minimising protests and audits, while the

choice architect gets their way. In its worst form, it explains why 100 companies are responsible for 71 per cent of global CO_2 emissions, (according to a 2017 Carbon Majors Report), while regular people are asked if we want to recycle fast or slooooow.

In a better form, it might help us landscape our garden ...

GOOD SYSTEMS WORK WITH NATURE

A well-landscaped garden makes nature's job a whole lot easier. Sometimes, decisions that you made once do their heavy lifting forever. Other times, you tweak your surroundings continuously to reinforce a behaviour you want. For best results, we want to work *with* our nature, not against it.

We all have certain goals in life, and many overlap. Most people want to be fit, happy, rich, sexy, respected, loved and free. But most people aren't all those things, and definitely not all the time. Some people are some of those things, some of the time, and some are none of these things, ever. When we want something but struggle to get it, it can feel extremely unfair to see someone else get it seemingly without trying. There's always some lucky bastard who can ace an exam without studying, some gym-avoiding freak who somehow has a sixpack when all they do is drink sixpacks, and some permanently honeymooning couple who bought bitcoin in 2011.

When you craft your environment and your routines, assume you are not this person. Assume you are the worst version of yourself and act accordingly.

What makes environmental design so attractive is the cost–benefit ratio. There are changes that we can make once that benefit us indefinitely.

My sobriety was made infinitely easier when I gave away my remaining reserves of drugs and alcohol. My fitness significantly improved when I installed a chin-up bar on a doorway I pass through regularly. And few things get me drawing faster than an open art book on a clean desk. Knowing this, I landscape accordingly.

That said, shaping your environment will only get you so far. Once we've figured out the lay of the land, it's time to make things grow, and for that we'll need compost.

TERRAFORMING 101

This might sound daunting, but it's nothing more than a cheeky bit of Sunday afternoon terraforming.

1. Pick a bad habit you'd like to quit or a good habit you'd like to adopt. When considering your response, it can be easy to get caught up in feeling that change is impossible. One way to sidestep this is by asking the question hypothetically: if I could click my fingers and magically stop or adopt a habit, what might I pick? Maybe you'd quit ordering takeaway food or start regularly attending a Zumba class.

2. Identify what might make this habit effortless for you to do and what makes it annoying. For example, 'indulging in takeaway food is made seamless thanks to the apps on my phone, and it's most annoying in their absence'. Or, 'Zumba classes are easiest when I've booked in advance, and most annoying when I'm comfy at home and don't know where any of my exercise gear is'.

3. Add or remove environmental friction accordingly. Using discipline to fight the takeaway habit is wasted energy when you can use laziness. Deleting the apps from your phone, logging out of them, or having them forget your payment details make ordering food an ordeal. The inner sloth who started the habit will now tell you it's not worth the effort. Similarly, the tiny steps standing between you and going to the Zumba class are all moments of friction. Finding your shoes, charging your Fitbit, wondering where the hell a drink bottle could be hiding. Each of these points is an opportunity for you to make a semi-legitimate excuse and skip the class. A simple way you can stack the deck in your favour is to put all your exercise things together, taking the friction points from a dozen down to two: get your bag and go.

CHAPTER 8

COGNITIVE COMPOST
(MAKE YOUR MINDSET)

Compost is a miracle: a bunch of dried leaves, food scraps, coffee grounds and (occasionally) literal shit goes into a big container. Worms and time do their thing. Beautiful fertile soil comes out and facilitates a blossoming garden.

We'll be doing the mental version: putting a whole bunch of scraps together and finding a simple way to turn them into a rich source of growth. To do this, we're going to get familiar with three components.

1. The pile of scraps *2.* The cognitive compost bin *3.* The can of worms

The pile of scraps represents all the excess thoughts banging around your head. Unprocessed thoughts are a huge contributor to Doom, the way rotting food scraps are a huge contributor to flies and a forever-smell.

But while mushy banana peels have a defined place to go – the compost bin – the irritating memories of office politics do not. The cultural expectation is that we let the waste fester in our heads until we no longer notice it. When life starts to feel gross, it's probably because we haven't cleaned up.

The way we'll be doing this is with journalling. The journal will serve as our cognitive compost bin. All the thought scraps we no longer need, all the shit we've been dealt, all the stuff that's attracting mental flies, goes onto the pages of the journal. This is how we clean our heads.

Now we release the can of worms! In the literal compost bin, worms help break all the organic material down into friable, nutrient-dense soil. In our cognitive compost bin, we'll be using a series of reframing questions. These will slither through our mental scraps, turning it into potent fuel. Like the worms, these questions are seemingly small but their impact is monumental.

A question as simple as 'Why do I love this?' is a worm that can start nibbling at an awful memory. 'How is this the best thing that has ever happened to me?' and 'Why is this my favourite failure?' and 'How would my life be worse if this terrible thing *didn't* happen?' are other little worms that can start turning scraps into abundance.

The result of composting is rich fertile soil. The result of cognitive composting is a rich fertile mindset!

MINDSET MULCH

Soil is to nature what an airfryer is to a thirty-something single dude who can't cook. It might not look like much on the outside, but it's the difference between life and death. Good soil giveth a forest and bad soil giveth a shitty dry tennis court, at best. As we'll be planting seeds – turning creative ideas into reality – we must make sure they're planted in the best possible soil.

Soil represents our mindset. Our mindset is something that we can cultivate, train and use to nurture creativity. A well-cultivated mindset can spot opportunity in the strangest places and create brilliant work out of the tiniest hints of ideas. It is the key to growth. A neglected mindset is, at best, a shitty dry tennis court of the mind that even the best ideas bounce straight off.

Just as soil determines a garden, your mindset determines your life. Its magic isn't found in what you make, but what you make it all mean.

Earlier we met Doom in the form of Dante's devil: a powerless and pitiful paper tiger. As we talk about gratitude, we find ourselves against another literary demigod of Doom. Fyodor Dostoyevsky, in *The Brothers Karamazov* (a bit of 1880s light reading), has the devil remark that, 'My best feelings, gratitude, for example, are formally forbidden solely because of my social position.' The message is that Doom and gratitude cannot coexist. To feel one is to not feel the other.

To bring this back from the hifalutin brink of Russian literature, I'm going to extrapolate this shit-to-gratitude concept as literally as I can, with a story you shouldn't read while eating.

ONE WAY TRIP

The luckiest day of my life began with violent diarrhoea and a taxi driver trying to rob me.

This was all set in motion a few days earlier when I met a fat, sweaty Brazilian man at a nearby bar. Before you come at me about that description, please know that he was openly fat and, like, really sweaty. Afonso, we'll call him. Not to protect his identity but because I forgot his name the second he told me.

Afonso and I were both alone at a bar, so we get chatting. We were both travelling through Peru and we both liked beer. Beyond that, it was a bit hard to tell what we had in common. Our chat was up against my lack of Portuguese and his lack of English, so we met in the middle and spoke Spanish. Neither of us were fluent, but the more beers we drank, the less it mattered.

'Yo tengo acid,' he said at one point, pulling a vial of LSD out of his pocket. Miming the international symbol for 'your head will explode', he reflexively slipped back into Portuguese to sing the vial's praise. He could have been speaking Ancient Aramaic and I would have got it.

Afonso and I proceeded to trip balls for the next twelve hours. As far as acid trips go, it was relatively uneventful. We marvelled at the patterns in the cobblestone streets, watched some live music, tried to eat, became confused by the concept of food, laughed at mirrors, avoided mirrors, went for a long walk, briefly lost each other, found each other, found a random third guy, stared at the stars, and when the sun rose we parted ways.

What's eventful here is everything that happened afterwards.

Whether it was something I ate or – god forbid – the free drugs a stranger gave me, as the day progressed I became viciously ill. I figured it was a hangover, so I drank a bottle of water and tried to sleep. Fate had other plans.

The next forty-eight hours involved shitting blood and vomiting bile. That first day came and went but the sickness stayed. The later it got, the less fluids I held onto, and the more veins I could see through the pale skin on my face. The next morning, on a mission to get more water, I collapsed in public. The locals who saw me didn't flinch; I was just another drunk tourist passing out on the streets of their once-sacred town. The tourists who saw me pretended they hadn't.

'Cam!' I heard a voice. 'Are you okay?'

I tried to turn my head toward the voice.

'Afonso ...?'

'No. Es me. Dario!'

Dario ... Dario ...

My dehydrated brain ran through its recent contacts list. Who the hell was Dario?

'Cam, you look very sick,' Dario told me.

'Very sick,' he added, notably horrified now my face was in full view.

'Oh!' I knew this guy. 'Dario!' It was the random third guy.

'Let's get you help, okay?' Dario picked me up like the angel he was and helped me back to the room where I was staying.

After he left, I continued to vomit bile and shit blood. I began to lose my vision, develop a fever, have spasms, and cycle through hot flashes and cold sweats. The situation progressed from 'it's probably a tummy bug' to 'should I be worried?'

It was around then that I remembered why I had even come to this town. I was meant to walk the Inca Trail tomorrow! The pre-hike orientation meeting was this morning, which meant I had missed it. 'That's okay,' I figured, 'I might have missed the meeting, but I haven't missed the walk.'

The Inca Trail isn't something you just rock up to on the day. It's a pilgrimage you book months in advance. The national park has strict limits on the number of people it allows to walk the route of ruins to Machu Picchu. And because the hike takes four days, if you're not there on day one, you're not there at all.

I wasn't a planner, but my childhood obsession with the Incas had made me one. This was the only thing I had booked for the entirety of this South American adventure. Hell, I had planned my entire trip around it. Descending deeper into fever, I began to comprehend the stakes. I had already paid for everything. I had boarded three planes to get to Lima and spent another twenty-four hours on buses to get to Cuzco. Now here I was, hours from fulfilling my childhood dream, and I was shitting myself in a hostel.

Then I got a knock at my door. It was Dario! He had found a doctor! Everyone seemed to be in a rush! The doctor pulled out a vial and a cartoonishly large needle. He inspected my bony body for a decent muscle, realised beggars can't be choosers, pulled down my pants and jousted the syringe into my butt cheek.

Later that night I began to recover, all thanks to the kindness of Dario and the doctor. Maybe I'd make the hike after all …

Except I had no idea where to go. Who was I meant to meet? What time? Where? Was I meant to bring anything? I imagine these questions were answered in the orientation meeting. The one I shat my way out of.

Nevertheless, I set my alarm for 3.30 am. My plan was to take a taxi to the bus depot and ask the first person who walked in.

Taxi trips at 3.45 am, anywhere in the world, don't have the best reputation. Customers are highly likely to vomit, yell, threaten, solicit, pass out, run or open a door at high speeds. And a less-than-honourable driver might spot an opportunity: drunk people are far easier to fleece than their sober daytime counterparts. Plenty of late-night cab rides buck these trends, but this wasn't one of them.

Shortly into the trip, I realised I was being politely robbed. The taxi driver, charming as he was, drove in the wrong direction, casually explaining that the further we got from my desired location, the more important it was that I pay him a large amount of money. As he

widened the gap between me and the bus depot, I felt my bucket list dream once again fade to dust.

I have no rational explanation for what happened next, and it still baffles me to this day. As the taxi driver and I were debating the finer details of my ransom, he turned down a dark alley, and what we found shocked us both.

'Did you do this on purpose?' I asked him, baffled.

'No ...' he laughed. 'No. Wow ... this is crazy!'

Call it god, luck or coincidence, but on this street was a crowd of people with gigantic backpacks, getting on a bus. And on that bus was the name of the company whose depot the driver was avoiding. The group saw us, and we saw them. I pulled out a cab fare's amount of money and the driver, still laughing in shock, conceded defeat.

The bus, which had never left from that obscure street before, had changed its schedule to compensate for a missed food delivery. My taxi driver's random choices miraculously coincided with this one-time-only pickup site - an address I would have learnt if I had been at that damn orientation!

I spent the next four days living out my dream, walking through mountains, jungles and ruins. I had never felt so lucky, so grateful or so astonished in my life. It's one of a few times I've pinched myself in earnest to check if I was dreaming. But every time I remembered where I was, how unlikely it all was, I became bewildered by the fact that I'll only ever live in one timeline. There were hundreds of ways this could have gone wrong, and I wasn't suffering in the wake of any of them. This was the purest gratitude I had ever felt. (It'd later find its way to third place, behind meeting my wife in the aisles of a supermarket, and the birth of our daughter.)

But make no mistake. Things had to go wrong. If I'd stayed healthy, gone to the orientation, found the bus with ease and had a lovely time, just as I expected, I doubt I'd have felt half the thanks I did. The forty-eight hours of

fever dreams and gastrointestinal hell followed by a taxi driver trying to rob me were integral to this feeling.

The greater the Doom, the greater the Bloom.

There's a truism that low expectations are the key to happiness. As I crossed another mountain, descending from the Altiplano of the Andes to the tropical clime of the rainforest, as a giant butterfly flew past my face and my lungs filled with oxygen, I felt this truism in full force. It was a Maslow's Hierarchy of Needs Speedrun: within hours, I had gone from death's door straight through to self-actualisation.

LUCK, GRATITUDE AND LOW EXPECTATIONS

This thin line between devastation and glory is more common than it might seem. Olympians know it when they stand on the podium – or watch someone else stand on it for running a fraction of a second faster.

In our culture of hyper-convenience, we take miracles for granted until they defy our high expectations. When you're streaming a movie and your high-speed internet suddenly slows down to a leisurely megabyte a minute, this is frustrating. But when you're broken down in the middle of nowhere, with nothing but a steaming car and zero reception, it's a different story. Here, finding a slither of signal, no matter how slow, feels like striking gold.

As our world caters to more and more of our needs, we've seen a rise in respect for discomfort. Ultra-endurance athletes expose themselves to unnecessary pain and seem to come out the other side with a palpable sense of inner peace. Getting tapped out in Brazilian jiu-jitsu has a way of putting work stress into perspective. And regaining your footing in a free solo climb, where a wrong move would have killed you, is gratitude guaranteed.

We can also micro-dose that feeling in a safe environment. We can take things away from ourselves temporarily, and let the phenomenon do the work for us. I liked the sleep on the floor thing … but maybe it's not it.

We can also access gratitude through the mental exercise of thinking about everything that could have gone wrong but didn't. All the cars that didn't hit us yesterday, all the water mains that didn't explode, all the mouth ulcers we don't have, all the dog shit we didn't step in, and all the times we weren't robbed at gunpoint. Imagine you're old and grey, chilling on your deathbed, when a genie appears and grants you a wish. Before you die, the genie lets you relive one day of your life. For some reason you picked this very day: the one you're living right now. Look around and try to figure out why.

All this is to say: gratitude can come to us in two ways. You get so lucky you can't ignore it *or* you realise how lucky you already are.

COMPOST BIN JOURNALLING

One of the easier places we can observe the impact of mindset is by actually noticing the thoughts we tend to think. Some thoughts are brilliant, others trivial, and some harmful. But all thoughts have the potential to be unhelpful in the wrong context. Solving a complex problem can itself become a problem if it consumes your imagination while you're driving. Rogue thoughts can disrupt the creative process. Rehearsing an argument that will never happen can be addictive. The pleasure we get from hypothetically dunking on a conversational adversary can quickly become a vice-like habit, like puffing on a mental cigarette.

The problem with these thought patterns is their opportunity cost. Just as drinking a bottle of vodka eats into a significant chunk of your day, getting stuck in thought loops is demanding on your time. When your brain defaults to unwanted rumination, it's not just that the rumination itself is bad, but it stops you from using your brain for good.

Rumination is not the type of thing we can think our way out of. If you were surrounded by rotting food, adding fresh food wouldn't be all too helpful. Thinking a fresh thought might keep you going for a bit, but eventually it joins the rotting pile.

We have to find a place to put it all – and just as compost thrives on decomposing food scraps, journalling thrives on unwanted thoughts.

There are many ways to journal, but they generally fall into two camps: unguided and guided. Unguided journalling is a rules-free mind dump of your thoughts onto paper. By capturing them on the page, you see they're not infinite, as rumination implies. To quote the great modern philosopher Shrek, 'Better out than in, I always say.' This type of journalling will form the compost bin part of our metaphor.

Guided journalling is about answering a pointed question with the intention of uncovering an insight. This type of journalling is the can of worms in our metaphor. By asking yourself specific questions designed to process your thoughts, you can turn excess waste into potent fuel for growth.

OPENING A CAN OF WORMS

Once you've got your thoughts onto the page, you can unleash the worms. Each worm is a different way to look at a situation. By seeing your shit from the worm's point of view, you start to process it into something useful. Feel free to create your own worms (reframing questions), but it's good to have a few heavy hitters in the can. Here are my suggestions, and some guided journalling questions to go with them.

WORM 1

SCIENTIST WORM (AKA WORMOLOGIST)

AIM: To learn from the data (shit).
QUESTION: What insights do you now know that you didn't have before? What conclusions can you draw?

WORM 2

ARTIST WORM (AKA HANDY WORMHOL)

AIM: To use the shit for self-expression.
QUESTION: What art did the shit make possible?

WORM 3
LAWYER WORM (AKA THE WORMY ATTORNEY)

AIM: To prove a (often counterintuitive) point that the shit is brilliant.

QUESTION: How is this the best thing that has ever happened to me?

WORM 4
SHAMELESS CAPITALIST WORM (AKA WORMILLIONAIRE)

AIM: To identify the resources hidden in the shit.

QUESTION: What do I have now that I didn't have before and how can I use it?

WORM 5
DRILL SERGEANT WORM (AKA THE ARMY WITH NO ARMIES)

AIM: To give you tough love.

QUESTION: Is this the best you can do?

CHAPTER 9

WATER
(FILTER YOUR FEED)

To bring our ecosystem to life, we need water! Water represents everything your mind consumes. Everything you see, hear, scroll past, click on, absorb accidentally, imbibe unknowingly, believe unquestionably, learn, unlearn, hate-watch, happy-watch, bored-watch and catch the tiniest little glimpse of in the corner of your eye.

If you've spent any time in metropolitan Australia, you'll be familiar with the Australian white ibis, more commonly known as the bin chicken. This nickname – a puzzle you've no doubt solved with assumption – came about because these birds look like weird chickens and hang out near bins. The bin chicken has flourished with urbanisation by learning to rummage through garbage. It's sad that a beak evolved for reed beds is now sifting through waste, but if all you have is trash then your next best move is to mine it for treasure. When life gives you bin juice, filter it for fresh water.

Bin juice is any mental input that makes your life worse, even if it markets itself as helpful or harmless. Fresh water is any mental input that actually makes your life better.

We can't avoid everything, and often complete abstinence poses a greater risk than consuming a tiny bit of poison (think vaccinations). So we're going to need to build a filtration system to ensure we don't spread the toxins – and to extract anything useful from the bin juice.

In my mid-twenties I had a problem with internet addiction, which was much like my problems with drug addiction except cheaper.

I should clarify that this internet addiction didn't occur separately to my drug and alcohol addiction. It was more of a T-Boz and Left Eye find their Chilli situation – these guys were made for each other.

I should also clarify that like most internet addictions, mine applied to a very specific genre of content. Some people are addicted to the highs of social media validation, others to porn. Some people get hooked on consuming injustice, and other people can't stop getting in community-messenger-board fights. My drink of choice was Doom ... but not the hard stuff.

I was obsessed with a quirky brand of Doom. Not the global mega Doom that clogs up the headlines, but the human-interest Doom that finds its way to the back alleys of subreddits you shouldn't click on. I don't know why, but I became transfixed. Soon, all this horrible content began to capsize my worldview.

I was primed for an unravelling, but could I take this sour energy and turn it into something positive? On a whim, I decided that for each horrible thing I consumed, I had to extract one healthy life lesson. And through this practice, I stumbled upon the actual truth behind every piece of cherrypicked Doombait.

In your tenure on the internet, you might recall coming across a rejection email a girl received from KFC. If this never graced your algorithm, the thing you need to know is that it was full of chicken puns. Apparently it's not enough to be rejected by KFC; you also have to stomach the line, 'We're cluckin' delighted

you're keen to join our flock, however at this moment in time your skills aren't the secret recipe the Colonel is looking for.'

Before my commitment to extracting wisdom from the trenches, the screenshot of this rejection letter was pure voyeurism. It was evidence that the world was a dystopian circus act teeming with tone-deaf brands, blind to their own flamboyant condescension. But after my mindset shifted, I found a more positive message behind the viral sharing of the email. Twitter was outraged, Reddit had a field day, and all the usual legacy clickbait sites wrote headlines about how it was 'brutal', 'cringe' and 'horribly mocking'. Everyone was instinctively on the girl's side; it was genuinely difficult to find *anyone* on Team KFC.

It's easy to see all the ways the internet divides people, but it's just as remarkable to see strangers care and come together in support. No matter your background, KFC using the phrase 'enough experience under your wing' while turning someone down is clucked-up. And the united response from thousands of strangers was the secret recipe *I* was looking for.

I was starting to learn the art of pulling fresh water from gigantic wells of bin juice.

TO CHANNEL A MEDIUM

In the twenty-first century, separating useful ideas from toxic ones is a craft worth honing. If we think about good, brain-nourishing information as fresh water, then we have to face the fact that most of our water is contaminated.

A reputable news website might hydrate our brain with measured and substantiated information, but it's still housed on the internet – a place where measured and substantiated information is borderline mythical. In the famous words of theorist Marshall McLuhan, 'The medium is the message.'

McLuhan believed that the nature of the media, such as books, television and advertising, had a greater impact on communication than the content it delivered. Writing in his 1967 book *The Medium is the Massage* (yes, you read that right), he warned: 'One of the effects of living with electric information is that we live habitually in a state of information overload. There's always more than you can cope with.' McLuhan predicted the rise of a global village, connected via a new technology that converged various forms of media – and by extension various messages. In addition to describing the technology of the internet in the 1960s, he also described how it might feel: 'Innumerable confusions and a feeling of despair invariably emerge in periods of great technological and cultural transition.'

For this reason, I believe media literacy is now a life skill. When all our messages come from the online medium, what is the actual message we're getting? While good journalism might be pure, it is contaminated by the clickbait packaging it needs to survive in an online environment. Whatever the message, the medium tells you the story of sensationalism, noise, chaos, anxiety and Doom.

So, how can we thrive in an information apocalypse? I believe we can learn from the monster that was Melvil Dewey.

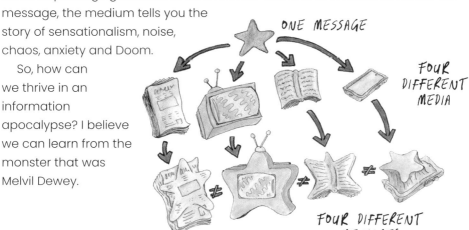

ONE MESSAGE

FOUR DIFFERENT MEDIA

FOUR DIFFERENT MESSAGES

THE DEWEY FILTER

When Melvil Dewey dropped his decimal system on the world, he solved a problem people didn't even know they had. However, before we dive into how Dewey can help us learn to filter, let's get on the same page about something important: Dewey was a dick.

Melvil Dewey was so hellbent on brevity that he changed his first name from Melville to Melvil to cut down on letters. Dewey was also a rapist, a racist and an anti-Semite. And this isn't one of those situations where you accuse someone from the past of having era-adjacent values. Even in the 1800s, his contemporaries thought he was an insufferable jerk. After Dewey formed a recreational club that banned a long and ugly list of anyone who didn't look like Dewey, other librarians rallied together to have his 'state librarian' status permanently revoked. Dewey, meanwhile, went about buying up the land next to his club out of fear that Jews would buy it first. Wow.

Dewey had some remarkable ideas about categorisation. He also had some remarkably grotesque ideas about categorisation. Dewey was, if nothing else, intolerant. And though his intolerance for people was pathetic, his intolerance for inefficiency was about to change the world.

Of course, taking tips from a racist rapist intuitively feels like a bad move. How much value can a person really bring if their personal life is riddled with horror? Surely there are lines that, if crossed, invalidate a person's entire existence, right?

Yes and no. Bad behaviour might deter us from learning ethics from someone, but it shouldn't deter us from learning ideas.

Dewey was up against the same problem that we all face today: how do you make sense of information overload? Like a handful of pedantic purists before him, Dewey took umbrage with the alphabet – just one of his many enemies. The order made no sense! If you want to learn about life, the universe and everything, would you really start with aardvarks? So Dewey did what any name-respelling nutjob would do: he made his own classification system.

The Dewey Decimal System works like this: all information has a number, from 0 to 1000. These numbers are separated into ten sections, and each section represents a different topic. If new information comes in, it gets an increasingly more precise decimal within one of the sections. Decimals allow for large categorisation (before the decimal point) and hyperspecialisation (after the decimal point). Dewey dazzled the library world with the key concepts of relative location and relative index.

RELATIVE LOCATION

The decimal system was universally adopted for two big reasons. First, there's the numeric advantage. Before this, a lot of libraries had used a system even worse than the alphabet: organising books by the order they got them in. With decimals, not only could a section expand as an area of knowledge did, but librarians had a much easier time finding and returning books.

RELATIVE INDEX

The second big reason is that Dewey's system facilitates spontaneous discovery. If you're in a library looking for answers to a question like, 'Magnets: how do they work?' it's unlikely you'll start with a specific book in mind. But if you go to the 538 section, you'll be treated to every book on magnets the library has. Surrounding these books are others on related subjects: electricity to their left, modern physics to their right. The alphabet, meanwhile, plonks magnets between Magna Carta and magnolias.

The system isn't flawless. Unsurprisingly, Dewey's racism found its way into his work – and not in a Justin Trudeau 'I wish you didn't see that' way. Dewey explicitly hardwired his beliefs into his system. Take the 200s, books on religion. There are thousands of religions, so one might optimistically assume that each religion got equal value on Dewey's shelves. Or at the very least, that the amount of decimal real estate reflected the relative size of the religion in terms of its members. Nope to both. Christianity got spots 200 to 290. The rest of the religions shared the cramped 290s. Islam, whose membership numbers are Christianity adjacent, was granted all of one number. DDC297 was a single integer with a universe in its decimals.

So you've got a guy who made libraries and learning phenomenally easier for the world. But he also classified 'homosexuality' under 'mental derangements' and black history as a 'social science' but white history as 'history'.

What do you do?

You filter fresh water from bin juice. Dewey's system is a baby we needn't throw out with the psycho racist bath water.

DOUBLE-DECKER DECANTER

Our filtration system will operate on the same two-tiered principle of Dewey's decimel system: relative location and relative index.

Firstly, we have our relative location filter. This is our mental map of the various channels through which we get our information, content and media. The relative location filter performs two functions: it filters out entire

RELATIVE LOCATION
Preselect the media and channels you do and don't want to consume

channels you think aren't worth your time, and directs you to channels that *are* worth your time.

This allows us to filter out a gigantic chunk of unnecessary noise straight off the bat. Some things that don't make it past my relative location filter are fairly standard. I (try to) avoid the classic cesspools of churnalism, ragebait, reaction channels, opinionated Doom and any website with a slideshow. Much of my filter stems from my puritanical response to my previous internet habits. Hence, the most impactful thing that my relative location filter blocks out is all short-form social media.

Having a simple rule that takes out entire channels for me is super handy.

Next, you can define the preferred methods through which you'd most like to consume information. When you want to learn something new, your relative location filter tells you where to start looking. In line with McLuhan's beliefs, by filtering out an unwanted medium we filter out its unwanted messages.

Of course, this filter is just the first point of call, and as we all know, it only takes a few minutes on the internet before you're knee-deep in detailed reports of humanity's greatest atrocities. This means that a lot of things still slip through the cracks.

This is where the next layer comes into play: relative index.

INTENTION

The relative index filter is what we'll be using to classify everything that does make it to your eyes, after you've already filtered the channels.

For a specific checklist, we'll once again turn to Dewey. Unlike McLuhan, Dewey believed that the medium was not the message, and, if anything, that the medium was irrelevant. He said: 'A library's function is to give the public in the quickest and cheapest way: information, inspiration, and recreation.

RELATIVE INDEX
Define your intention before you start consuming

If a better way than the book can be found, we should use it.' (He'd be furious to know I can't locate what book this is from.) It is in this spirit that we'll craft our relative index filter.

Before we look for mental input, it can be powerful to first ask what type of input we're really looking for. Are we seeking mostly information, inspiration, or recreation? Lots of content falls into all three groups, but filtration is less about what's available and more about what you want from it. When media consumption becomes compulsive, we lose intentionality. We consume habitually instead of for a purpose. By predefining the purpose, we can start to tackle information overwhelm.

It's not uncommon for people to experiment with making their media standards as high as possible, either for a period or for good. Just as people engage in nutritional diets, some people engage in media diets. A notable example of this is what I'll call the 'Lindy diet', wherein people only consume 'Lindy media'. Don't worry, I'll explain.

The term 'Lindy effect' stems from a cohort of mid-century comedians who'd meet up to dissect all things show business at NYC's Lindy Delicatessen. This bagel-adjacent think tank noticed that their peers who opted for rapid and constant television exposure tended to have shorter careers than the people who paced themselves. With the phenomenon defined, outsiders saw similar trends in more places than just comedy careers. This morphed into today's definition of the Lindy effect, wherein a piece of longstanding media, by virtue of its endurance, is likely to stay in the public consciousness for as long as it had been around. Every piece of media, through the Lindy lens, is said to be, at most, at its halfway point in relevance.

Take an old piece of media, like the Book of Genesis, and compare it to a new piece of media, like this video my buddy sent me of a barber absolutely ruining some kid's day with an aggressive haircut copied straight from a Pokémon gym leader. The Lindy effect suggests that Genesis, which has been around for roughly 2500 years, will last at least another 2500 into the future.

The psycho barbershop content with its psycho royalty-free trap beats has been around for four days. The Lindy effect suggests it will stick around for at least another four. Maybe it'll stick around for 2500 years too. Time will tell.

If you're really looking to detoxify your mind from content, you might want to consider giving your relative location filter a Lindy number. This number will refer to the number of years that a piece of media has been around. You might pick three years or thirty-three, and you might find it works best for movies or for everything but movies. How you set up your relative location filter is up to you.

As a kid, it took me longer than it should have to understand the phrase 'you are what you eat' because no matter how many bananas I ate, I never became one. It clicked one day when a teacher said, 'Eat good food, feel good, dude.' The same applies to what we put into our minds.

FILTERING THE BIN JUICE

Let's build our own two-level filter. With the relative location filter, we refine what we consume, and with the relative index filter we refine our intention behind why we consume it. The steps might sound obvious, but actually doing them can immediately remove a lot of stress.

1. **RELATIVE LOCATION:** Write down a few rules about where you think you'll never find content that makes your life better. Then build a list of media outlets you deem critical and nuanced, mediums that you resonate with, and platforms that you get a lot out of. Bring back the landscaping lessons we've learnt and get busy blocking, un-bookmarking, clearing your history, and unsubsribing (or maybe subscribing – to your local library).

2. **RELATIVE INDEX:** Next time you unlock your phone to procrastinate with any of your filter-friendly content, ask yourself: do I want information, inspiration or recreation? If you're bold, you might add: how will I know when I've got what I need, and at that point, how will I stop? Or if you want to keep it simple: why am I unlocking my phone? Perhaps landscape with a phone background that asks these questions for you.

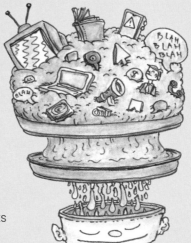

RELATIVE LOCATION
What you consume

RELATIVE INDEX
Why you consume it

CHAPTER 10

SEEDS VERSUS WEEDS
(CHOOSE YOUR CHANGES)

Now that we've built our foundations, landscaped our garden to our liking, brought in compost and worms, and got the water flowing, it's high time we planted some seeds!

Seeds are the ideas we want to see come to life. We must plant these with a sense of openness. They might not become plants, and that's okay. They might look different to the plants we expected, and that's okay too. We might plant them, nurture them and grow a forest far greater than we first thought possible. But we also might plant them, get frustrated with their lack of immediate growth, label them defunct, dig them up and plant some other seeds.

Continue this cycle long enough and not only will there be no forest, that garden we've spent so long preparing will likely get overrun by weeds.

We can procrastinate in so many ways, but the ways that do the most damage are the ones that don't set off the smoke alarm. If we procrastinate on Groundwork altogether, we notice. But if we do the Groundwork but procrastinate on planting seeds, weeds start to pop up. And if we don't look at the garden bed closely, we might not notice that things are going wrong. From a distance, weeds can look like lush growth.

This is the equivalent of being offered a great creative opportunity and a job you don't really want that pays just a little more. It's having a book deadline and instead discovering just how urgently the laundry needs folding. Both options feel like growth, but only one is the growth you truly want. Instead of planting a seed, in its place you get a bunch of weeds.

This discourages us from monitoring the garden too closely because on some level we know that it won't be pretty. The plausible deniability of progress will be replaced by regret. Every time you're too scared to start that 'someday project', commit to a routine that you know will improve your life, or even just be honest with yourself, the weeds win.

The thing about weeds and seeds is that they compete for a finite amount of garden space. One grows at the expense of the other. The hard part is that weeds grow easily and are immediately rewarding. Seeds, on the other hand, take constant work and always more time than you think. But in the long run, weeds make it harder to cultivate what you want, while seeds bring you to Bloom.

Or, in the far more memorable words of the Olympic weightlifter Jerzy Gregorek, 'Easy choices, hard life. Hard choices, easy life.'

Seeds = things born of intention and cultivation, which get you towards your goal = hard choices, easy life

Weeds = things that happen to grow when you are complacent = easy choices, hard life

To tell seeds apart from weeds, add a time horizon. What would this growth, if continued for five years, amount to? What would this day, if continued for five years, make your life look like?

A weed might not look like a huge problem at the time, the way slacking on your habits for a day is a non-event. But over the course of five years, it makes things messy and unmanageable.

Weeds grow quickly and easily. They give the appearance of a green garden, the way a week spent stagnant and rotting in bed gives the impression of relaxation, or how seven Aperol Spritzes makes someone look happy, or the way twenty daily Instagram stories about 'that CEO life' signifies success. Weeds are shortcuts to what a goal looks like, and not to the goal itself. Rather, their presence puts the goal further out of reach.

The trick is to not forget about the garden now that you've done the Groundwork, because the garden won't forget about you.

WHEN WEEDS KILL SEEDS

Did I ever tell you about the time I quit my job with a news article?

Of course, quitting is not where the story starts. That began a few years earlier.

When I finished high school, I was in an interesting financial predicament. My family had slipped below the Australian poverty line just in time for the last years of my education, which would usually be a bad thing. But in my case, that of a seventeen-year-old thrill-seeking idiot, this was a gift. Partial amounts of our government welfare were directed into my personal bank account, ready to access the minute I turned eighteen.

If this premise sounds like the recipe for a train wreck, that's because it is.

I spent all that money on drugs, which, miraculously, kept the train wreck at bay. Instead of doing *all* the drugs, as my haircut at the time suggested I might, I engaged in a bit of pharmacological distribution. For the next twelve months I followed my passion and created a fairly debilitating drug addiction. I supported this financially, as so many do, by helping other people create habits of their own.

In true middle-class crackhead fashion, I paired this endeavour with tertiary education. I began my first year of university with bright dreams for my future. I had chosen to study astrophysics, but after I discovered amphetamines, these high hopes dissolved in my hopelessly high head. They were no match for cash, drugs and attention.

I got kicked out of uni on a Monday. My distinct thought at the time was 'fair enough'. I packed my bags and kept moving.

I knew that it was probably a wise move to have an actual shot at getting a degree. So I made a vague decision: 'I'll enrol at another uni for next year and figure it out from there.'

Naturally, I deferred doing any of this. Summer came and went and before I knew it the university year was starting up again. With a week to go, I was enrolled absolutely nowhere. Worse still, the formal application process had been shut for over a month. I had apparently hit the point of no return, and realised it all too late.

So I did what anyone desperate for a degree would do. I pinpointed the university that was most likely to accept me a week out, picked a fun-sounding degree and emailed the head lecturer. The specifics are important here. The degree was in advertising/marketing at a notoriously debaucherous party university. There was no consensus on what marks a student needed before enrolling, which meant the uni was unlikely to refuse people, and even less likely to refuse people who lie about having high marks.

Within twenty-four hours I received a reply. The head lecturer looped in the admissions officer, adding the note: 'Please enrol this 95 UAI student!'

A few days later I started my new student life, earning a degree in advertising. A few months later, I adored it. A few years later, I graduated with a new passion. I really fell in love with the craft – or, more specifically, I fell in love with what I *thought* was the craft.

Firmly free of my dropkick past, I was excited to get a corporate job! This may seem unlikely, but such is the thought process of the uninitiated. Advertising's best advertising job was advertising itself. The ad industry had a reputation for being cool, thanks less to actually being cool than to its knack for propaganda: theatrical pitches, shiny awards and an atmosphere that felt like the cutting edge of *something*.

I bought into this image completely and applied for the most ambitious graduate jobs I could. There are thousands of things I'm awful at in this world, but writing a cover letter is not one of them. I got the dream job.

In case you haven't already written off your narrator for being entitled and ungrateful, I'm confident this next section will seal the deal.

I started working and immediately hated absolutely everything. Like Holden Caulfield from *Catcher in the Rye*, I began writing off perfectly fine things as 'phoney'. Unlike Holden, I did this all without charm. I committed crimes against the vibe and I paid for none of them.

Time, like an ant, marched on. I, also like an ant, began to feel like a cog in a machine. On the one hand, this was a good thing. I grew more competent at the job, which became a source of meaning. On the other hand, this meaning was undermined by the meaninglessness of the entire operation. What were we even doing here? Making noise? Selling pointless products to people who don't even want them?

The glass broke on what I thought advertising was, both in the context of its product and its production. Ads weren't creative; they were a prescriptive cover band of creativity at best. And my expectations of a 'cool industry' were destroyed by the reality of it being 'just another corporate industry that happens to have beers and a few silly posters.'

And then I decided to sell some old jackets.

I needed money, so I put the jackets up for sale on my personal Facebook page. It was 2014, and we were still a few years from having Marketplace. For each jacket I wrote a satirical caption. On one of them, I said, 'Hey guys I'm selling all this stuff so I can become a digital nomad.' Being a 'digital nomad' was all the rage in 2014, so it was the first thing that came

to mind. The joke, forgive me for explaining it, was that 'all this stuff' referred to three jackets totalling $15.

Lost in translation, as it deserved to be, this one line caught the attention of an old journalist friend. Tasked with writing a story about the 'digital nomad' trend, she sent me a message asking if she could interview me about 'my new life path'. Starved for significance and novelty, I said yes.

When she rang me at 11 am, I was three coffees deep. The impulsivity that had long derailed my senses kicked in and I decided to commit to the bit. I pretended that I was a few jacket sales away from becoming a digital nomad, which I had also decided was my new lifelong dream. My mouth did the talking before my brain could get a word in.

Afterwards, I was struck by the haunting feeling that I shouldn't have done what I just did. I reconciled this with reality. 'I should not have done that,' I conceded, 'but hey, no one's actually going to see this fluff piece, right?'

If that last line felt like foreshadowing, go ahead and thank your instincts. Because you know who saw 'this fluff piece'? Fifty-five thousand people. Instead of being the blog filler I was expecting, thanks to a particularly slow news day and a positively trending interest in digital nomads, this article became the top one on News.com for twenty-four hours. 'Meet Campbell Walker: The Real Life Into The Wild Guy' read the headline, innocently placed inches from an old photo of me in Peru, at the end of the Inca Trail. All that gratitude and luck I'd felt when the photo was taken was nowhere to be found.

My stupid name and my dopey smiling face were given their first ever serving of internet exposure. And it did not go well.

Within a few minutes of the article going live, I looked around the office to see it on every computer screen. If a slow news day wasn't enough, apparently it was a slow workday too. My coworkers read every word, including these ones: 'My job is a petri dish of corporate cringe. I thought I would be surrounded by creativity, but instead

I'm surrounded by people intoxicated by job titles and quirky socks.'

The next thing I knew, I was in 'the secret meeting room' with a bunch of higher-ups. To my surprise, and to their credit, they were less angry than they were confused.

'Did something happen?' one of them asked. I didn't know how to answer this. In my early-twenties brain, the 'thing' that 'happened' was the whole damn system, man! 'Nah,' I said. 'Just a joke between friends.'

Afterwards, shaken, I slunk back to my desk and committed the cardinal sin of the internet: I decided to read the comments.

This traumatised me more than anything else that day. 'Who puts out a press release for a holiday?' snarked one. 'Oh, how I loathe youthful exuberance,' stung another. This was my first experience of being torn apart by online strangers.

I lasted two more painful months at the job, seeing my contract through to its end. Those months were defined by judgemental looks in the hallways from people I'd never met, and I didn't blame them. I fell into a dull depression and began lugging around a dozen new bags of self-consciousness.

I didn't know what to do, but I knew I had to do something. Fuelled by shame and superstition, I threw a Hail Mary. I might be insensitive, naive, impulsive and neurotic, but I didn't have to be a liar.

So, with marginally more consideration, I decided to sell all my stuff and become a digital nomad.

FROM WEEDS TO SEEDS

The next three months were characterised by creativity, Cambodia, friendship, failure, motorbikes, monkeys and expensive mistakes. This turned into three months of mourning, Minneapolis, insultingly insufficient funds, Craigslist and self-disgust. I came home with my tail between my legs and a filthy attempt at a top knot.

But despite how gross I looked, a new realisation was dawning: that the pain of the previous year wasn't stinging quite as much as it had before.

That stumpy little ponytail sprouted from my thinning hairline like the first flower of spring breaking through the forest floor. And I followed suit. My curiosity felt insatiable. I felt a sense of Renaissance, as the suffocating arrogance of my early twenties morphed into the slightly more tolerable arrogance of my mid-twenties. I did things I'd never done before. I applied for a job as an artist's assistant. The first thing the artist said to me was, 'Your cover letter was the best one I've ever read.' What I lacked in literally everything, I made up for in cold emails.

I was in full spring Bloom. It seemed that my short stint as a fake digital nomad and an accidental detour in the American Midwest had acted upon me the way winter might. The break from the norm, the lack of pressure and the literal snow had replenished the autumn leaves of my embarrassed soul. I'd stumbled across the seasonal pattern that would form the lifeblood of Cultivated Creativity.

KEEP GOING

In Doom, it was obvious to tell when we were stuck. But getting trapped in perpetual Groundwork can be a little harder to spot.

There is a trap that lurks in all self-improvement messages, no matter how genuine and non-scammy they might be. The trap is getting addicted to the feeling that the future is going to be awesome … without taking any action towards it actually becoming awesome. When a self-help book can make you feel like everything is possible, it's tempting to stay in that headspace. When you're preparing for a project, that project is perfect. The second you touch it, you lose your fantasy.

Getting people hooked on inspiration is so lucrative that it's spawned the entire industry of personal development programs that are totally not cults. Paying for endless seminars and questionnaires in the hopes that you'll finally 'actualise your you-ness', progressing through arbitrary levels until you 'potentiate your selfhood' - these are all symptoms of getting stuck in Groundwork.

When Groundwork becomes Groundhog Day, we see people endlessly prepare for their dream life. While they live on the precipice of planting seeds, which they'll totally do just as soon as they get the soil perfect, the world doesn't sit around and wait. Their garden sprouts weeds.

This approach to life is a sort of high-functioning complacency. It's nowhere near as bad as Doom, but it's not exactly pleasant. Instead of taking action towards your goal, you spend all your days pulling out weeds, convincing yourself that you'll plant a seed one day. But when?

When I tore apart my life with a dumb jacket sale and an even dumber phone call, I had let my garden run on autopilot. I had done the Groundwork to get a job, only to follow it up with nothing. Instead of harnessing the momentum I'd created, I let the land go to thistles. It was time to pull out the overgrown weeds and plant the seeds of the things I actually wanted in my life.

It's taken some serious sweat to get to this point, but it's not yet time to coast. The Doom is at bay and the Groundwork is set, but you didn't come this far for weeds. It's time to Bloom.

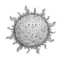

MEET FUTURE YOU

1. Write a letter from your present self to your future self.

2. Write a hypothetical reply, from your future self to your present self.

The more we identify with the reality of the future, the more likely we are to act in a way that serves it. For this reason, I recommend making 'Future You' as real as possible. Imagine them in detail. What does their day look like? How did you become them? And if you really want to drive the point home, use a face-aging filter so you can see who you're writing to.

This person exists, and you're building them today. We're taking that classic line about how the best time to plant a seed was twenty years ago, and the second best time is right now, and we're introducing ourselves to the tree-to-be to remind ourselves that the seed will be worth planting.

PART 3

BLOOM

WHEN IT COMES TO CULTIVATING PLANTS, any advice must be filtered through the lens of your own (garden's) circumstances. You could painstakingly follow every instruction when it comes to planting cacti, but if you do so in a harsh Siberian winter you'll still end up disappointed.

In life, we can copy the routines of successful people all we want, but if we forget to account for the seasons, we're likely to end up just as empty-handed as the Siberian cactus farmer.

Grinding and hustling like a Navy SEAL who wakes at four in the morning, hits the gym for two hours and then 'crushes it' might look like a wonderful blueprint. Who wouldn't want to have the life that discipline builds? But if you're looking after a sick parent and have a baby on the way and a debt collector at your door, you shouldn't beat yourself up if you fall short.

Just as it's unwise for our Siberian horticulturalist to blame themselves if they see no growth, so too it is for you. Instead, their first step should be to diagnose the problem: this plant only grows in the desert spring. So, perhaps the new plan is to grow an alpine plant. As for you, maybe four o'clock alarms only work when there are less factors at play. The new plan is to build a routine tailored to someone in the throes of overwhelm.

Too often, when things in our life go awry, we default to blaming ourselves. Sometimes this can be healthy. For example, by 'owning' mistakes, you remind yourself of your power to change the situation. This is often regarded as 'noble', and it's easy to see why. It's also easy to see how this Pavlovian self-flagellation can backfire. When life is beating you with baseball bats, your family is once again cementing its status as dysfunctional, and your car, fridge and phone conspire to synchronise their deaths, you might be in the market for a bit of grace.

Some plants grow in summer and others in winter. Some processes work wonders when we're in a flow state and destroy us when we just want a hug. Techniques designed to pull us out of ruts can, when all cylinders are firing, be the same techniques that cause them.

We've done the Groundwork to get our garden fertile, but we still have one final journey ahead of us, into our creativity.

Nature is dynamic. It constantly changes but in a way that is somewhat predictable. We call this dynamism the seasons. In this part, we'll be talking

about bringing creativity to life through four distinct phases: curiosity (spring), focus (summer), catharsis (autumn) and rest (winter).

The pattern of creative seasons can play out over the course of a day, a month or many years — even your whole life.

Consider the creative seasons as four states of mind that we each need a little bit of. All four serve a purpose.

In the following chapters, we'll explore these mental habits in depth. We'll learn how and why to cultivate them in our lives, how they affect each other, and what happens if they're ignored. Above all, we'll learn how these four tenets keep Doom at bay, harness our Groundwork and set our gardens to Bloom.

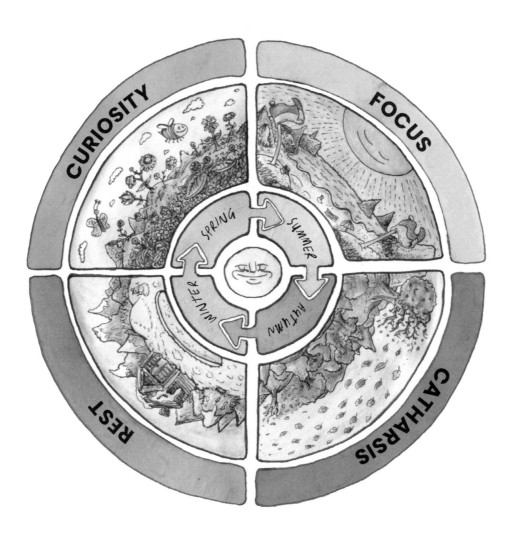

122

CHAPTER 11

SPRING
(CURIOSITY)

Ah, spring! When new flowers Bloom, baby birds learn to fly and antihistamine sales go through the roof. Spring is alive! The hibernation is over. New sprouts break through the ground and new leaves unfurl on the trees. The sun stays a little longer and the world comes out to play.

 Spring represents our curiosity, the desire to learn anything and everything. It's your intellectual thirst. It's the part of you that wants to read pulp sci-fi for ten hours straight, learn Swahili and investigate those weird lights in the sky Tom Delonge keeps banging on about.

But curiosity mode isn't always helpful: it can pull you off course. And while curiosity is a fundamental part of creativity, it's not enough on its own. Sprouting flowers are lovely, but eternal spring is its own kind of hell. At some point you want your sprouts to mature into plants, the same way we want moments of curiosity to turn into something more substantial, like a project, a passion or a career.

If you're only focused on seedlings, you might plant things you shouldn't, or convince yourself that nothing you do grows big. You might find that you hop from project to project, confused at why nothing has taken off, forgetting that things need time to grow. Half-finished projects, half-pursued hobbies and half-baked ideas become souvenirs of shame.

What the sprouts need is sunlight. What scattered ideas need is *focus*. That being said, focus also needs scattered ideas.

A PERFECT 5000

When my daily screen time hit six hours, I knew I had a problem. Internet addiction was worse for my outlook on life than drugs ever were, but far easier to harness for good. Drugs had no silver lining beyond the initial high; the internet at least left me with some stuff to talk about. But drug addiction has the grace to ruin your life efficiently. Content addiction is a master of disguise: you're not addicted to the news, you're 'informed'; you're not addicted to social media, you're 'tapped into the culture'.

Your worldview is constantly evolving, with changes that span from granular to grand. It can be imperceptible, like imbibing a set of principles held by your book club. Or maybe an emergency snaps us into a new way of thinking. When it turns out your book club is a book-*burning* club, you instantly question your decision to join. And then there are times when your worldview is transformed by a mobile game you play while taking a shit.

The game that did this for me was called Chronophoto. It's deceptively simple. You're shown five photos from history and you have to guess what year each was captured. You

take cues from things like photograph quality, fashion and technology. If you guess correctly, you get 1000 points. The further you are from the year, the fewer points you get. The highest score you could theoretically get would be 5000. This is made difficult by the fact that the photos come from across the globe, and borderline impossible by the fact that 1924 looks near identical to 1925.

The photos are largely mundane. Some are iconic moments of twentieth-century history, but mostly they are of regular people living their lives. The more I tried to get a higher Chronophoto score, the more I had to learn about everyday people in the past. I learnt that shoe spats were in fashion in the early 1900s, that bell hats had a moment in the mid- to late-1920s, and that the superior bowl haircut is from the 1940s. I learnt about the evolution of the Model T car, the biplane, the tank, the motorbike. I fell in love with CRT computers from the 1970s, cameras from the 1960s, and industrial design from the 1950s. I combed through protests and penny-farthings captured on grainy slates of early cameras, right through to phone photos of face masks and screenshots of Zoom. Which all brought me a sense of joy but also relief, because it meant I wasn't pouring over *something else*.

I had made the New Year's resolution to quit social media … eight years in a row. Just removing the habit didn't work; I had to replace it.

Many people in recovery from alcohol addiction emphasise replacement over removal. Removing alcohol from your life leaves a void in which you're likely to think about how much you'd love a wine. Replacing the pub with tango lessons, however, gives you a new spark.

So I gave myself a new goal: get a perfect 5000 in Chronophoto. If looking at everyday life had moved me so much, why not spend a little more time doing that?

Along the road to my petty goal, my screen time dropped, my faith in people rose, and my knowledge of mid-century wallpaper went stratospheric. It wasn't

until I hit the perfect 5000, months later, that the gravity of the habit hit me. It wasn't only about replacing social media with Chronophoto. It was about replacing complacency with curiosity.

This weird little game had been my lowbrow path to experiencing a highbrow truth: unlocking the potential of your curiosity is methodical, not random. The key is lowering the stakes, simplifying the goal, and removing any doubt about what actions you'll be taking next. As the great psychologist Mihaly Csikszentmihalyi wrote, '... to become deeply involved in any activity it is essential [to know] precisely what tasks [you] must accomplish, moment by moment.'

Curiosity is always itching to get out. It wants to explode. But it thrives best when it's a byproduct of a low-pressure straightforward activity that strays off your usual path. This might be painting if you're not a painter, swimming if you're not an athlete, or baking a cake that only you will eat. For me, it was the goal of guessing five correct years in a row in a game of historical photo trivia.

Curiosity is in all of us, but certain things obscure it. In my case, curiosity had been smothered by hours on social media. If you learn a new language, you'll likely come across the maxim 'use it or lose it'. Mental skills, like muscles, are best when exercised regularly.

HIGH AND LOW STAKES

When it comes to creativity, curiosity is about going with the flow and seeing what you make. Jordan Peele's mantra 'follow the fun' captures this concept neatly. It takes the pressure off a creative pursuit needing to be anything more than an experiment. Often this low-stakes frame is so powerful, it facilitates an artist's greatest work.

To understand what a low-stakes activity is, let's have a look at a high-stakes one. Consider the gladiators of Ancient Rome. When they prepared for battle, they were gearing up for a life-or-death fight. One wrong move could leave them kneeling in a pool of their own blood, at the mercy of their opponent, a hungry crowd and an emperor eager to entertain. A high-stakes activity is one that might result in people taking one last look at the world before being publicly decapitated.

This is the opposite of what we want to cultivate here. Gladiators cannot engage in play or experimentation. Curiosity will kill them, as it did the cat.

We want to feel the polar opposite of this. Our aim is to find an activity where the stakes are so low, we can happily push random buttons to see what happens.

This next story will be a challenge to communicate in writing, so I'll need you to meet me halfway. This is because it is the story of a sound.

You know the clown song? The circus song? That goes 'do-do-doodle-oodle-oo-do-doo-do'? The song you might hear played on a high-pitched whistle while bumbling clowns stumble and flop out of a tiny car, roly-polying over each other? It's made up of whimsical staccato notes prancing down a chromatic scale, before flicking around and back up like the clowns themselves. 'Do-do-doodle-oodle-oo-do-doo-do'? You know it? Yeah, you know it.

That song is called 'Entrance of the Gladiators'. Composed in 1897, it's a military march dedicated to the Roman Empire. In the mind of the composer, Julius Fučík, the sound that perfectly encapsulated the ferocity and awe of warriors as they took to the Colosseum was – you guessed it – 'do-do-doodle-oodle-oo-do-doo-do'. The song our modern ears associate with clowns was meant to depict gladiators.

Granted, Fučík's march was meant to be played slower than the clown version, and the chromatic tippy-toes become more menacing at this tempo. Less granted, this in no way absolves the song of its unnaturally conspicuous clown vibes.

If '1812 Overture' immediately brings to mind the name Tchaikovsky, why does 'The Clown Song' not do the same for Fučík? Instead, 'The Clown Song' joins the league of orphan melodies that drift through the public consciousness, detached from their composer and name. Why is it that one piece could be 'pretty good' in its original form, and take over the world in another? Would

Fučík's name be more known had he just embraced the bozo of it all?

In fact, the playfulness the world fell in love with in this music was actually there from the start.

When Fučík wrote his iconic clown bop, his main inspiration was not actually gladiators. That came later. Fučík was writing a standard polka-like march. This meant brass instruments. But this was 1897 and instrument technology was having a moment. The latest piece of tech: the gears on the horns that allowed for fast-changing chromatic notes. Fučík wanted to see what it could do, so he wrote a piece to specifically push this new technology to its limits. 'March of the Chromatic' was its original name, but Fučík promptly shoehorned gladiators in, presumably to hide the fact he just wanted to play with tech.

The song was only tough for four years. By 1901, the march had found its true calling in the circus.

We're not always right about what we're capable of making. In fact, we rarely are. This is why curiosity is fundamental to the creative process. It allows us to explore beyond our limits and not judge ourselves for trying new things.

When Fučík followed the fun, it led him to brilliance. But a global hit song was never his intention here. Like so many artists or a kid with a new gadget, he was simply fascinated by the new technology of the time. While he left the world with 400 other songs, driven by dreams of commercial success, his magnum opus was the result of pure curiosity.

Of course, if Fučík had taken the same approach to being an *actual* gladiator, he would have been Fučíked. Experimenting is great in some contexts, but terrible in hand-to-hand combat in the Colosseum.

Less metaphorically, let's say you're a singer. It's important to explore the range of sounds you can make when you're experimenting in the studio. Curiosity is how you develop your craft. But in the context of an on-stage solo Broadway number, it's important you put your craft to work.

You might find you actually thrive when the stakes are high. Hence, curiosity is only one piece of the puzzle. To harness it into something more intentional, we'll need to focus. However, just as summer needs spring to germinate the plants it so deftly grows, focus needs curiosity to sift through myriad ideas to find one worth developing.

Curiosity is not about achieving an outcome. It's about discovery. Later, this discovery will more than likely help you perform when it's time to focus. But the less you worry about results, the more curiosity will serve your soul.

Similarly, the rebirth of spring is exploratory. When pollen floats through the wind, we don't expect it to have a plan. It goes with the flow. We don't boo the bees that buzz to one flower over another. This would be mean. When a new stalk breaks through the ground, we don't immediately try pick its fruit. We give it time to grow.

We've explored how to instigate curiosity through low-stakes goals. Now let's look at how to remove our desire to judge things before they're fully grown. When ideas are still forming, giving them labels can nip them in the bud. Call a fledgling curiosity a success and it tends to be crushed by pressure. Call another newborn thought a failure and we cut ourselves off to all the ideas it wanted to lead us to.

To avoid premature judgement, remember that you are a gardener, not a carpenter. When it comes to curiosity, it's our job to work on the context, not to shape the ideas into a predetermined outcome.

DISCOVERY

When I was fourteen I had the unfortunate curse of enjoying musical comedy. Worse still, I had the self-awareness of a fourteen-year-old. With these poorly paired weapons, my friend Barnaby and I entered our local Battle of the Bands. This concert was full of kids who liked rock, but that didn't stop us auditioning with our musical comedy act. When

we got told we were in and would have our first ever live audience, I was elated.

On the night of the concert, I remember *feeling* the volume of it. The concert was overseen by some local teachers who handed out earplugs at the door. I guess if anyone got hearing damage, the teachers could at least say they tried. Those earplugs were doomed to live and die deep in the pockets of shin-length jorts. This show was about ROCK.

When the time came, Barnaby and I walked out on stage, our only instrument was the borrowed acoustic guitar on my body. We had imagined this moment in our heads for weeks. We began our routine … but instead of cheering, the kids started booing. We had no electric guitar, no drum kit, no cover of Hoobastank's 'The Reason'. The audience decided we had murdered the vibe. Then, an innovative member of the booing crowd remembered the earplugs. He rescued them from the recesses of his zip-off cargo short's ninth pocket and threw them straight at my head. This proved popular. The other kids also found their complementary ear plugs and gave them a complementary toss at the stupid acoustic comedy act on stage. We were but clods in the village square, trapped by the wooden stocks of our song's remaining verses.

We kept playing and they kept throwing. We hit our final line and the lights were cut immediately.

That was the first time the world told me music was not for me, but it wasn't the last time I asked.

On the surface, I had failed. But in the eyes of curiosity, I had learnt. Unfortunately, because I was fourteen, I didn't quite learn the right message.

A few years later, like any guitar-playing dork, I started a band. But this time, I was twenty and knew everything.

I liked punk music, so we made punk music. I liked offensive singers, so instead of singing I made horrible experimental sounds with my throat. After my traumatic acoustic comedy experience, I decided that the last thing I wanted to be was approachable. Instead of inviting people in with jokes, I would subject them to graphic stories barely even appropriate for therapy. This garnered a small following of damaged but wonderful people.

The thing that legitimised this project was the lyrics. While a lot of them were jarring and heinous, our small fanbase felt the truth of them. We never amounted to anything as a band, but many of my lyrics ended up as tattoos on people. Recently I met a girl who had a tattoo of a line I'd forgotten but was happy to be reminded of: 'Things are gonna be fine in the morning. Which morning, no one ever specified.'

That song also has a line about masturbating while someone bleeds to death, a slur I'd been called a lot, and the declaration 'I'd rather be a dick than dead inside'. I'm not proud of it, but creating intentionally obnoxious music is – if nothing else – punk.

I met that girl because we had a mutual friend in Tinman. Tinman and I had written that song together. Several eras later, here we were, seeing words we once wrote etched forever on someone else's skin. That was the last time I saw Tinman alive.

Things are gonna be fine in the morning. Which morning, no one ever specified.

To me, this is the ultimate argument for experimenting with new things. We don't know how many mornings we have left.

Unfortunately, as our band's music spread, we ran out of weirdos. The normies hated it and let us know. 'The worst voice I've ever heard in my life' became such a common epithet that it began to feel like a unique selling point.

People were generous with their opinions about how they'd hate to be stuck in traffic to our songs. One line in a surprisingly favourable review sums up that chapter best: 'Awful vocals but some of the best lyrics penned by man.'

The message I received from all of this: shut up and write. Had I never tried, I'd have no message at all.

The aim with creativity isn't to succeed at everything we attempt. Success is nice, sure. Curiosity, however, is not about achieving a goal, but informing it.

CORRIDOR THEORY

Imagine two people standing in a very long corridor, looking down a long hall, while a clock ticks backwards from one hour. Along the walls, as far as they can see, there are doors to new rooms.

The first person is told to think before they act. They wonder, 'Which of these rooms will I explore first?' They deliberate, they question themselves, they question the concept of a room altogether and curse the very system that put them there. Eventually they check out a room, but before they know it their time is up.

The second person acts before they think. They walk down the corridor, and if a room catches their eye they enter it, have a little look around and then bounce on to the next room. By the time the clock is up, the second person has not only seen lots of rooms, they've also seen just how far the corridor goes.

After this exercise, each person is asked to pick which room they want to live in for the next ten years of their life. Person A, having only explored one room, picks that one. Better the devil you know. Person B has seen twenty-odd rooms and picks their favourite.

Now compare this to life. Each room in this corridor represents a direction you can take your life. One room might show you reinventing ice cream, while another room shows you as a marine biologist's psychologist ('And how does that make you *eel*?'). Different rooms are different paths. By entering a room before the hour is up, you can try various interests on for size. Curious about high fantasy world building? Walk into the room and give it a shot. When it comes to interests, act before you think.

So why the time limit? Short answer: death. Long answer: you want to limit the amount of time you're trying things out in order to also get the satisfaction (and compound interest) of sinking your teeth into something for a while.

Person A, who settled in the one room they explored, has become a pharmacist who lives in the same town they grew up in. A fine path, but they're left wondering what might have been. Person B tried beekeeping, teaching, building car engines, slam poetry, nursing, landscaping, stand-up comedy, millinary, and then discovered their undying love of welding! They dedicate their life to metal sculptures and live happily ever after ... kinda. Upon remembering they also love building car engines and hats, they decide to make those metal sculptures drive across the desert wearing the fanciest fedoras known to man. Now that's a craft!

So, what's the point? First, trying new things leads to better ways to do other things. Our path lies more often than not in the combination of unrelated paths. Zoë Bread liked making art, but her lo-fi taste left her with no compulsion to sculpt the next David. She was wickedly funny, but (in all likelihood) a bit too bizarre for an open mic night. But put these two elements together, mix in her wonderfully weird energy, and you end up with her unforgettable surreal comics, plucked straight from a zine found only in a fever dream.

Second, paralysis through analysis doesn't just affect your time. It affects the data you take in. With less data, fewer options are available to you.

But the third takeaway is that indecision is not a vantage point from which you assess your options. It's an option in itself, and not a great one. Assessing things in your head is unreliable thanks to layers of biases and preconceptions. The actual way to assess your options is to try them.

AIRBORNE VERSUS BEE-BORNE CREATIVITY

In nature, there are two main ways plants are pollinated: via the wind (airborne) or via bees. Technically, it's actually any natural element (wind, water, etc.) and any insect, but wind is the most common element and bees are iconic.

Airborne pollination is a quantity game, bee-borne pollination is a quality game. Creativity works in a similar way. Sometimes new ideas form out of sheer quantity. If you come up with fifty ways to write a murder mystery game, there's a decent chance one of them will hit. Other times, coming up with ideas is more calculated. You spend more time defining the problem you're trying to solve and really nailing it. Both approaches are equally valid.

Airborne curiosity is about learning whatever your heart desires, with no guardrails. This might be as simple as replacing Instagram with Wikipedia. Two hours in the Wikiverse will produce enough pollen to create *something*. In a non-phone-based practice, it might

look like getting a library card, asking your friends questions you've never asked before, or letting the odds and ends at the op shop pick your next hobby.

At its extreme, the story of airborne curiosity is best told through Danny Wallace. Jaded by the grind of daily life, Danny decided to bring his world back into Bloom with a single rule: if someone asks you a question, you have to answer 'yes'. Danny went on to create a micronation, win (and then lose) $25,000, and ultimately have his story turned into a Hollywood movie. He was not aiming for a specific goal. Instead, he played the numbers game.

Airborne curiosity is a good antidote to analysis paralysis. When we overthink, we create stagnancy. We know we want to do something, but we're not quite sure what that something is. Airborne curiosity cuts through the overthinking by putting lots of feelers out and seeing what sticks.

Bee-borne curiosity is about making problem-solving fun. If you know the outcome you want, this type of curiosity is about finding ways to make discovery attractive to you. Let's say your goal was to learn to draw. As a digital practice, this could be finding ways to only use your device to serve that goal, like watching tutorials or using illustration apps. In an analogue context, this might look like embarking on a drawing-a-day challenge.

I want to end with some more bugs.

Cheryl Hayashi is an esteemed biologist whose life's work revolves around spider silk. Her career is full of fascinating and important things that I won't pretend to understand, but if you do, there's a lot of terms like 'whole-gene cloning' and 'ribosomal DNA'.

This obsession wasn't innate – Hayashi wasn't a bug-collecting kid. Instead, it began when she was doing field work in Panama and was given the task of hand-feeding a colony of tropical spiders. It awoke something in her. She's likened her work to being in on spiders' 'ancient secret'. A chance encounter one day; the world's leading expert on spider silk the next.

This transformation, to me, is the story of malleable wonder – it's always present, but we need to notice it, follow it, and let motivation thrive. For all the productivity hacks out there, nothing can replicate curiosity.

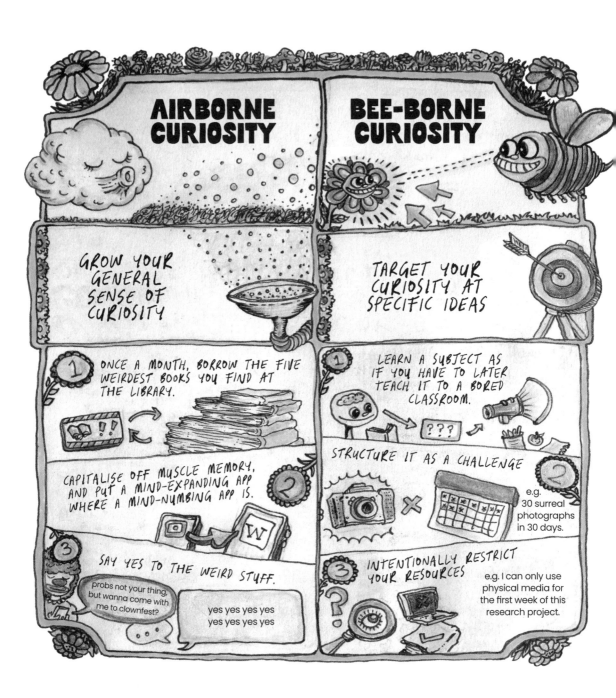

CHAPTER 12

SUMMER
(FOCUS)

Summer has long days, warm nights, and gets people out of the house the way screaming gets people off your bus seat. You might remember summer from its shout-out in the musical *Grease*, or that 1997 horror flick that claims it knows what you did with your last one.

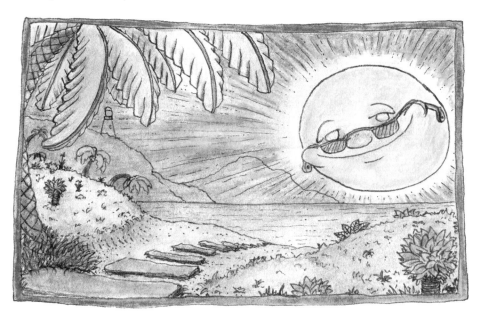

Creative summer is when our energy, drive and hunger are at their highest. We're geared towards action. The strength of creative summer is our ability to get stuff done.

The old saying 'make hay while the sun shines' applies here. When you're hot, you're hot. Milk it. Make a tall glass of sweet summer hay milk.

But what exactly do you unleash this creative energy on? What project is the right project? How do you know which one to prioritise? You need to *focus*.

MONSTER TRUCKS

When was the last time you had a good honest chat about monster trucks? If your answer is, 'I've never had one of those chats, and I'm not overly keen on starting now,' hold that thought.

A monster truck is a colossal off-road vehicle with oversized wheels and – in almost all cases – a wicked paint job. Trucks first became monstrous in April 1981, thanks to a man named Bob.

Bob had a problem. Like most construction workers, Bob Chandler drove a pick-up truck, but unlike most pick-up trucks, Bob's whip was mechanically rare. His 1974 Ford F-250 used a soon-to-be-obsolescent drive train, made at a time when Ford treated innovation like a chore. If that last sentence made you tune out, don't worry. This won't be on the exam. What is important to this story is that Bob struggled to get parts. Local mechanics were seldom equipped to work on his car, so – seeing the market gap – he opened his own shop. But how could he get the word out there about it?

'What if I combine my truck,' thought Bob, 'with a bigger truck?' In a proto-Xzibit-esque ride-pimping, Bob replaced the under-assembly of his pick-up truck with one from a military top loader. This is the car equivalent of surgically transforming a human into a centaur. The truck was raised. The bottom of the door was now a

regular car's height off the ground. And as for Bob ... he was just getting started.

Bob called his giant freak vehicle Bigfoot. He entered it in races and car shows, impressing the hell out of (I assume) literally everyone. Bigfoot was bringing Bob business. Then, naturally, Bob wanted a VHS tape of Bigfoot to play in his shop, so one April day he set up a camera to make a home movie. He pressed 'record' and then drove Bigfoot over the top of two dilapidated cars, crushing them like a pair of Pringles on the pavement.

This video went 1981-viral, and so did the idea of a massive, modified truck squashing old cars. In no time at all, the first monster truck race was televised, Bigfoot was on its way to icon status, and Ford offered Bob a sponsorship. By the end of 1983, monster trucks were a 'thing'. The subculture exploded, attracting people who pushed the boundaries even further.

Notice, however, that Bob didn't set out to make monster trucks a thing. His goals evolved with his situation. His original aim was to fix his own car. His mission grew to the size of a shop, which came with the realities of promotion. Through action, necessity and constraints, Bob walked down his own creative corridor gathering skills and ideas along the way. Curiosity had guided his competence, so when Bob struck gold with Bigfoot he knew exactly why and how to direct his focus.

And that's how we got monster trucks.

CONSTRAINTS

How problems create solutions (and monster trucks)

Your car breaks down | and you can't find anyone to fix it | so you fill the gap in the market yourself.

Now you have a shop | but you don't have customers | and you need to advertise without spending money.

So you use a broken car | and whatever else you have | to fill your shop with people.

Customers wait around bored while you repair their car, enduring daytime TV | so you make a video that revheads actually want to watch | and people *really* like the video. The monster truck is born!

YOU

Your creativity might involve a monster truck, but it also might not, which is why it's time to shift our focus from Bob to you.

In spring we avoided the question, 'What do you focus on?' In summer, we get to answer it – in a two-part process.

First, we'll tackle the inverse: what *don't* you focus on?

Second, we'll make it actionable: what do you focus on *first*?

Straight up asking yourself what to focus on is often useless. It gets you thinking about potential answers, but because of its open-ended nature it doesn't encourage you to arrive at one. Unless an answer feels truly magnetic, we feel no progress. Far more telling is the question's opposite: what should you *not* focus on? Every answer, whether it's repulsive or just unlikeable, feels like progress. The options of what you're going to do get narrowed down.

Above all, there's one thing you should never focus on. Nothing.

SOMETHING OVER NOTHING

When I was twenty-five, I was a dumb donkey. Let me explain.

There's a classic self-help parable about a donkey who is both hungry and thirsty. To the donkey's right is a bucket of water and to its left is a big bowl of premium donkey food. The donkey has everything a hungry, thirsty donkey could ask for, but the donkey isn't sure which one to go to first. It eyes the water, then the food, then the water, then the food again, trying to decide. A few days later the donkey still hasn't picked which one to go to first and drops dead. The end.

Indecision is a killer. Sometimes it kills donkeys, but when I was twenty-five, it killed my self-respect.

Indecision often masquerades as something more noble. Sometimes it'll dress up as 'just assessing my options'. Other times it wears the perfect clothes of 'quality control'. Indecision also gets a kick out of pretending to be a defence against loss, informing you that 'if you pick one path, you forfeit all the rest'. What indecision neglects to tell you is that it *too* is a path you pick. And while it's true that a decision leaves you with only one option, indecision will eventually leave you with none.

The indecision that was plaguing my dumb-donkey twenty-five-year-old self was what to do with my life. This is about as common as mid-twenties thoughts get, and also about as paralysing. How can anyone move forward under the weight of that question? It felt as though I was running a race in the Olympics with a blindfold on. Without knowing which way I was meant to move, every step I took was an anxious one. But I knew that if someone just pointed me in the right direction I'd be able to run towards the finish line, and I was fairly sure this person existed and would be here any minute now.

Therefore the best move, I reasoned like a donkey, was to wait for that all-seeing person's arrival, and – to pass the time – do some stretches and complain about how late they are.

The moral of this story is not to be a vocal angsty mess until someone gives you tough love, but that's what happened so maybe it is. At the time I was working at an art studio with a husband-and-wife powerhouse artist duo, Gillie and Marc Schattner (also known as Rabbitgirl and Dogman). At work, I would whine away, lamenting the fact that I wasn't getting anywhere in life despite how much I wanted to. My stretches on the Olympic track were scattered creative executions. I could play music, draw, write poems … why wasn't anything happening? Why wouldn't that magical person just show up?

'You know what your problem is?' Marc finally snapped one day. He was a prolific sculptor, a generation older, and eons wiser. 'One day you write a poem, the next day you draw a picture, then the third day you make a song!'

'And?' I asked. 'Is there something wrong with being creative? Isn't the whole idea of art that you take your raw inspiration and make whatever comes to you?'

'If you want a hobby!' He looked at me, point blank. 'Is that what you want?'

'I want to get paid to be creative, so I can keep being creative,' I lamented.

'So you want a career?'

'I want to do *something*, but I don't know what. All I know is that I can do a bunch of different stuff.'

'So can everyone,' he bit back, bursting my bubble. 'Do you think a bunch of scattered pieces are somehow going to all add up to some magical career? You're laying a single brick of a thousand different houses and expecting a mansion!'

'But isn't that restrictive?'

'Restrictive is the point! Creativity is also about mastery and recognition and cohesion and signature and – yes! – that means making a certain type of thing, even though you can make ten things that aren't that thing. Do you think Yayoi Kusama is itching to paint more polka dots? Do you think I want to sculpt another Dogman? Sometimes yes, sometimes no! Creativity isn't just about a single artwork, but the story those artworks tell together. It has to be legible before people even look at it, and that means that art and branding and story are all inseparable.' Marc's rant built to a crescendo. 'If you have the audacity to want to be paid for your creativity, you better have the humility to play the game. Pick one thing. Draw it every day for a year. Until you do that, don't tell me you don't know what to do.'

Message received. Pick one thing and draw it every day.

In the spirit of decisiveness, I picked my one thing that afternoon. On my way home, I walked through a park I crossed every day seeing things I saw every day. In Sydney this meant a flurry of professionals all thinking they're the most important person on the street, flocks of tourists taking selfies, and – everywhere you looked – ibises. Or, as we now know them, bin chickens.

So I picked ibises. Instead of going home, I went straight to the pub and asked for some paper to draw on. They gave me the back of a betting sheet and I drew nine ibises. Immediately I could see the power of compounding in creativity. At the time I didn't know what to call it, but I felt it all the same.

Over the next year I drew an ibis every day. This practice allowed me to get better at drawing, and develop habits around finishing my work, sharing my work, getting feedback and building an audience. When it became boring, I started adding social commentary to the ibises to keep myself entertained. The social commentary hit home more than the drawings, and Marc's advice began to hit home more as well. He wasn't telling me to draw one thing because he thought I'd game the system by becoming 'the ibis artist'. He was telling me to start, because focused action is the only way to become anything.

If we return to the idea of being blindfolded in the middle of an Olympic arena, we can ironically perhaps see the full picture.

What I didn't realise is that the blindfold was not tied around my head but very loosely wrapped. The only thing it was actually attached to was the position where I was standing. If I ran in *any* direction it would rip right off and my vision would be back.

The problem was, I thought that for me to start, someone had to tell me what to do. In many ways Marc was the person, and I'm beyond grateful for that, but that wasn't the lesson he was trying to teach me. Underneath his advice was the blunt truth that no one was coming to save me now, nor would anyone be there in future moments of indecision. The only person I was waiting for was me. If you're reading this, waiting in the stadium, then let me play the role of Marc and tell you that the only person you're waiting for is you.

SLAP ON THE CAP OF CONSTRAINTS

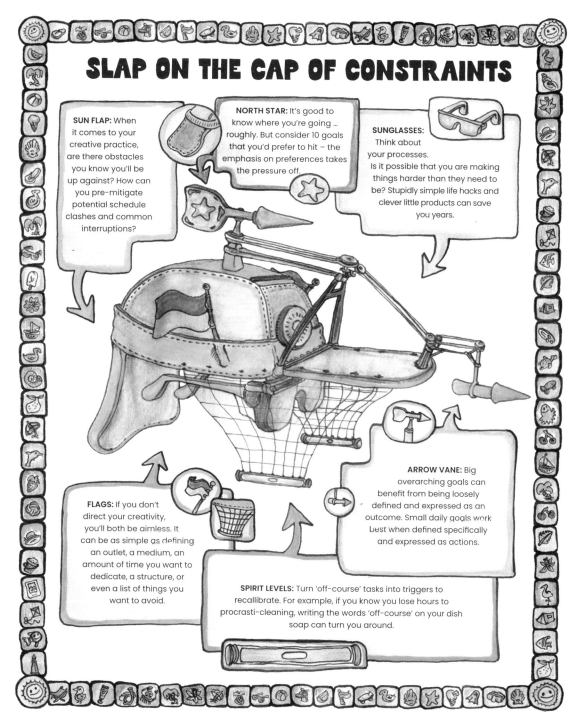

SUN FLAP: When it comes to your creative practice, are there obstacles you know you'll be up against? How can you pre-mitigate potential schedule clashes and common interruptions?

NORTH STAR: It's good to know where you're going ... roughly. But consider 10 goals that you'd prefer to hit – the emphasis on preferences takes the pressure off.

SUNGLASSES: Think about your processes. Is it possible that you are making things harder than they need to be? Stupidly simple life hacks and clever little products can save you years.

ARROW VANE: Big overarching goals can benefit from being loosely defined and expressed as an outcome. Small daily goals work best when defined specifically and expressed as actions.

FLAGS: If you don't direct your creativity, you'll both be aimless. It can be as simple as defining an outlet, a medium, an amount of time you want to dedicate, a structure, or even a list of things you want to avoid.

SPIRIT LEVELS: Turn 'off-course' tasks into triggers to recallibrate. For example, if you know you lose hours to procrasti-cleaning, writing the words 'off-course' on your dish soap can turn you around.

CHAPTER 13

AUTUMN
(CATHARSIS)

Summer doesn't skip straight to winter. It takes its time by strolling through a pile of crunchy crimson leaves called autumn. When the leaves fall from the tree, the tree has to let them go. Their colours shift from green to lime to mustard, then orange, ruby and crimson, and eventually they fade into an earthy brown and join the forest floor.

In our world, we'll embrace similar tiny deaths. This is the process of catharsis. Just as the tree is not the leaves that fall, we are not what we create. Catharsis helps us let go of things we're holding onto that hold us back. Ideas about who we are that no longer serve us, dreams we need to lay to rest, projects that died a long time ago – unless we let them fall, we'll never make space for new ideas.

Catharsis is the act of cleansing yourself by expressing yourself. When we put genuine emotion and vulnerability into our creativity, it shows. This doesn't necessarily mean that every piece must explicitly be about the human condition. Catharsis is less about the output and more about the input.

The thing that makes creativity worth pursuing is emotional connection. In our era, one of creativity's biggest threats is the content farm. The desire to connect emotionally is replaced with the desire to feed an algorithm, the creative act becomes void of the thing that makes it creative, and the art and the artist both suffer for it.

The way we get around this is with catharsis mode. This might manifest in an input-only sense, wherein you find catharsis through the process of dancing just to see how strangely you can move your body, cutting shapes on your kitchen floor, exhausting yourself until your dread becomes joy. Or your catharsis might include output too, like finding the truth of how you feel and turning it into a stand-up comedy routine. Either way, you're connecting to the truth of how you feel in a non-judgemental way. When this feeling is channelled into creativity, we experience a therapeutic effect, and the work is stronger for it too.

THE JOY OF SAD SONGS

Quick hot take: I love country music because it's good. Remember that for later. We'll lasso back.

When I was twenty-four I had the most awkward conversation of my life. I got legitimately starstruck. The most embarrassing part was that the star who struck me wasn't even particularly famous. He was, to most people, some guy.

The star/some guy was a musician called Sean Bonnette, the singer in a band called AJJ. When you have to say 'a band called' before the band's name, they are – by definition – not very famous. To further paint just how not-very-

famous Sean Bonnette was, he was standing in the crowd watching his support band, being bothered by absolutely no one.

Except for me, who thought he was a genius, a god, and my own personal hero. So I tapped him on the shoulder and said, 'Hi, Sean, every lyric you've ever written has hit my soul and made me stay alive when I thought I didn't want to and I love you.' Real normal move from me. Now Sean's a cool guy, so he says thanks. But I'm not a cool guy, so I just stare at him. Smiling. Not blinking. For – like – twenty very long seconds. I looked like that happy Voldemort meme.

Then he says, 'So you know any good places to eat around here?'

It took me five unexaggerated seconds to register what he had asked. Like a normal human being, he was trying to make conversation. He was on tour from the US, and my Australian accent told him I was a local.

And like the paragon of cringe I was, I said, 'Thai food. I have to go. I love you. Bye. I love you.'

My god, I'm smooth.

But fascinatingly I felt no embarrassment – and trust me, I really should have. Instead, I loved the uncool, terrifying way I silently smiled into his soul, because those moments are the driving force behind Sean Bonnette's lyrics and by consequence the encounter itself.

In fact, Sean's debut words on the iconic second AJJ album, the 2007 *People Who Can Eat People Are the Luckiest People in the World*, were, 'Rejoice despite the fact this world will hurt you!' So I did. On track two he sings, 'I'm afraid if I go out I'll outwear my welcome.' Tick. In my favourite of his songs, he belts out the line, 'Everybody is afraid of me.' But when I met him, it was the other way around.

Like so many artists, he turned his pain into art to process it. Screaming his insecurities to folk-punk music was his way to overcome them. He confirms this process in a song called 'Sad Songs (intermission)'. The chorus summarises the

reason he makes art: because singing sad songs 'keeps my spirit light and my conscience clean'.

This is textbook creative catharsis. So, how can we do it? Are there ways to facilitate keeping your own spirit light and your conscience clean?

The answer can be found not in the song's lyrics, but in its constraints. What makes 'Sad Songs (intermission)' stand out is that the band changed genres for it. For three and a half powerful minutes, AJJ are unapologetically country. And they know this country sound isn't for everyone – they even finish by singing that they don't mind if you don't want to listen to this song and instead use it as a chance to step outside.

This, to me, captures the essence of creativity. And I don't think any other genre would have worked. The Woody-Guthrie-like melody feels so familiar and predictable, so borrowed, that the song at first appears to lack creativity. But this country charm is a Trojan horse. The 'yee' brings your guard down, so the 'haw' can hit you. And in a way, this is the story of every country song: a step back, an honest look, an underdog and a gut punch. Six strings, three chords and no expectations that anyone will care. By constraining the music to a handful of instruments and melodies, the singer's best chance of self-expression comes through their words. If you're feeling anything other than rosy, like most people most of the time, those words will exude vulnerability. When that pain wants to escape, and you only give it one place, it makes itself at home.

VULNERABILITY + CONSTRAINTS = MASTERPIECE

Just as the leaves of one season must fall to make room for the buds of the next, parts of our life fade to make space for parts to come. It can be sad to watch them fall, but it is far sadder to live with no room to grow.

Similarly, your falls in life are beautifully rich in colour. Just as the autumnal palette gives us a fleeting treat, a similar marvel can be spotted in times of fledgling instability. The autumn of your creativity is when you have access to the echoes of your summer drive and the depth of the oncoming winter. This is the space in which iconic break-up albums are written, harrowing poetry is born and the tortured artist paints a masterpiece that will posthumously define their

genius. It is a phase fertile with works steeped in sorrow of what could have been.

But while life's what-could-have-been's haunts you, saying goodbye to your creativity's what-could-have-been is often an unexpected delight.

LOSE YOUR LEAVES = MAKE THE MASTERPIECE

When you create something, you reduce the potential of the individual parts while increasing the potential of their sum. Before the 'Mona Lisa', Leonardo da Vinci had a canvas, paints and tools. And before writing that last sentence, I had the chance to pick literally any other painting and I went with the most basic option. But my delete key is in the shop, so we're sticking with it.

Before that little-known, indie-darling portrait, Leonardo's art supplies had the potential to be combined into a staggering number of things. He could have painted a cow, a castle or a proto-kitsch scene of dogs playing poker. Beyond art, he could have burnt it all to stay warm or fashioned an avant-garde hat, altering the course of millinery history forever. But with each brushstroke, the potential of these elements began to reduce.

To quote every suburban dad ever, 'When you buy a new car and take it for its first drive, it immediately loses thirty per cent of its value.' When da Vinci's canvas was first struck by paint, it immediately lost a gigantic chunk of potential. All the non-painting options were ruled out. As the first ochre hues began to reveal themself, the focus tightened further: the canvas could no longer be a Rothko-esque tribute to the colour pink. This process of reduction continued until da Vinci had ruled out every option that wasn't the 'Mona Lisa'.

The canvas, paints and brushes became the most famous painting in the world – but they also could have become kindling. This is why making things can

be at once so magnetic and so painful. Every other canvas that has ever existed in the world did not become the 'Mona Lisa'. But at some point it could have.

It's ludicrous to think about the creation of the 'Mona Lisa' as though something was being lost. But it's easy to think about our own creative work and identify that feeling. If we're not sure what we end up with, we might fear that embarking on a project is a waste of time.

Creative catharsis, however, reminds us that the outcome isn't the reward. The process of getting it out of your head, for better or for worse, is enough.

So we have curiosity, focus and catharsis. These three pieces of the puzzle can make for some world-changing art. You get curious about a new idea, you have the discipline to bring it into the world, and you fill it with feelings that make it timeless. These three modes can make you a masterpiece, but not forever. As a trio, these three drives ultimately steer us toward exhaustion. To make this process sustainable and enjoyable, we need to add one more piece …

THE ART OF LETTING GO

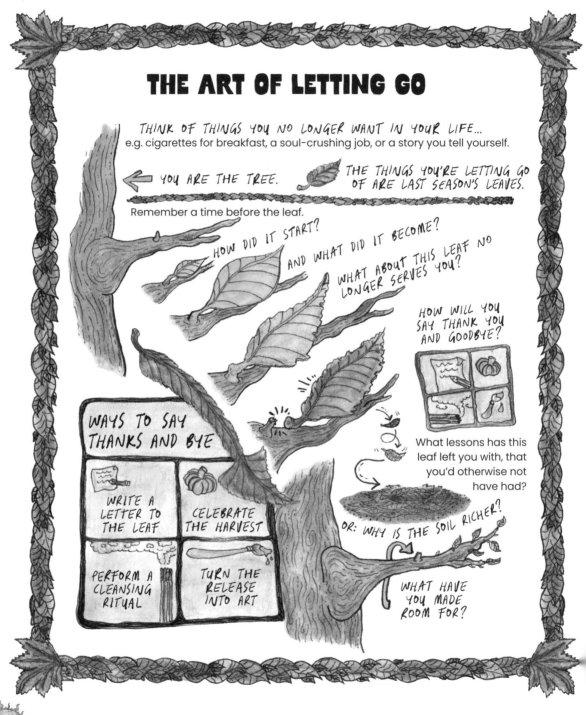

THINK OF THINGS YOU NO LONGER WANT IN YOUR LIFE...
e.g. cigarettes for breakfast, a soul-crushing job, or a story you tell yourself.

← YOU ARE THE TREE.

THE THINGS YOU'RE LETTING GO OF ARE LAST SEASON'S LEAVES.

Remember a time before the leaf.

HOW DID IT START?

AND WHAT DID IT BECOME?

WHAT ABOUT THIS LEAF NO LONGER SERVES YOU?

HOW WILL YOU SAY THANK YOU AND GOODBYE?

What lessons has this leaf left you with, that you'd otherwise not have had?

WAYS TO SAY THANKS AND BYE

WRITE A LETTER TO THE LEAF	CELEBRATE THE HARVEST
PERFORM A CLEANSING RITUAL	TURN THE RELEASE INTO ART

OR: WHY IS THE SOIL RICHER?

WHAT HAVE YOU MADE ROOM FOR?

CHAPTER 14

WINTER
(REST)

The leaves have left the trees looking cold, wiry and underdressed. The weather has kindly requested that you keep your jacket on. Even the sun has decided to sleep in and knock off early. Welcome to winter. Temperatures drop, frost

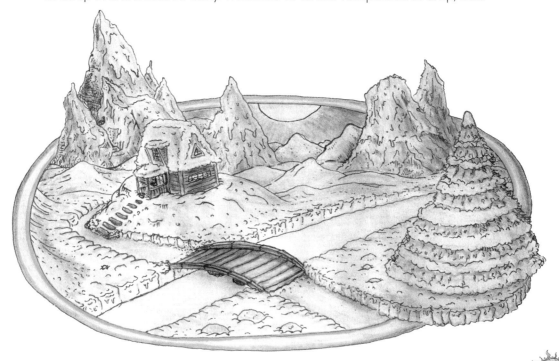

falls, snow forms and our wardrobes get a workout. Our breath becomes visible and kids the whole world over pretend to vape.

Having lost its leaves, the tree in our garden looks vulnerable, but during winter it will become stronger. With every gust of wind, the tree's roots thicken, turning adversity into strength and sustainability.

Creative winter is the time to rest, recover and indulge in creature comforts. With a mind exhausted from summer's output and autumn's spectacle, consider winter your creative hibernation. And like the tree, you will come out the other side stronger.

The final mental habit we need in order to Bloom is rest.

In winter, your best bet is to cosy up, bunker down and put a pinecone in the fireplace. Creative winter sends a similar message. The noisy chaotic world you inhabit hasn't changed, but you have. Like a tree without leaves, you're more open, more sensitive, more vulnerable. Consequently, exposing yourself to this noise feels like exposing yourself to a blizzard. It's time to enjoy your own company for a while and come back out when the weather's on your side.

During creative winter you let your mind rest, away from the speed of our hyperconnected world. But be careful! Resting, today, is easily mistaken for many things that are *not* resting.

Most notably, scrolling might seem like resting simply because it doesn't feel productive. But consuming a barrage of high-calorie, watch-to-the-end, sped-up puppy videos alongside the worst human atrocities imaginable is a world away from rest. Your body might be relaxing when you scroll into the void, but your mind isn't. It does its job, looking out for threats – of which there are plenty – and sends signals that keep you vigilant. It responds to the content's slot-machine delivery system, crafted in the spirit of monetising addiction, chasing a high it will never hit. Your mind starts spiralling into thoughts about how you come across, how you ought to be and how you fall short. Between feeling on edge, compulsively addicted and extremely self-conscious, you can barely breathe.

Worst is when you blame yourself for feeling this mental fatigue. 'I rested, so why don't I feel good? I stopped working – I even did mindless scrolling – and now I feel worse! What's wrong with me?' Guilt is common, as though we are having a weird reaction to a normal situation rather than a normal reaction to an incredibly weird situation.

The trick, I believe, is to think of the world as a raging blizzard. Your phone, your portal to this chaos, is an invitation to stand in the raging snowstorm. 'Why am I anxious?' becomes, 'Why am I cold?' And, 'How do I stop this feeling?' becomes, 'How do I leave the blizzard?'

You go indoors. You find the log cabin on the mountain and take shelter. You shake off the residual snow, take a deep breath, and take stock of your newly acquired sense of stillness. Creatively, this looks like stepping back from the external stimuli that keeps you in panic mode and into a pace that actually lets you pause.

THE CASE FOR A CREATIVE OFF-SEASON

There's a reason professional footballers don't play a competitive game every week of the year. They would burn out and dramatically reduce the length of their career. So they have an off-season.

Guess what? Creative pursuits benefit from an off-season too.

This is especially the case now creativity has become inseparable from content. The pace at which we create things has conformed to the pace of the platforms we share them on. Instead of listening to our own capabilities, the internet has set the standard for how much a person should make. What we consider 'enough' is forever increasing. But frequency isn't a function of how much a person *enjoys* making something, rather how much a person *can* make. This pace is not human. It is the frequency of technology: always on, full-speed, forever.

We need an off-season. From our creative work, and maybe even from ourselves.

No one is immune to becoming annoying with enough time and proximity. Not even our favourite people are exempt. This proximity limit extends, for better and for worse, to ourselves too. We've spent all spring, summer and autumn with ourselves, through all sorts of moods and weather. You might, understandably, need a break. It's nothing personal.

We can't physically do this, as far as I'm aware, so we'll have to resort to mental trickery. Perspective, empathy, insignificance and wonder are just what the doctor ordered.

AWE

Rest and awe aren't two words that get used interchangeably. Rest connotes relaxing in a hammock; awe is more a mind-blown-watching-aurora-borealis situation. But there's an overlap in their domains. Both rest and awe are pressure valves for the brain. They replenish the soul. Rest gives your mind space, while awe gives it perspective.

This relationship has a physiological manifestation. Your eyes send signals to your brain to let you know how alert – or relaxed – you should be. When your gaze expands, say to take in a colossal vista, your eyes tell your brain to tell your body to relax. When your focus narrows in on a single thing, like a huntsman spider crawling across the wall, your eyes – appropriately – let your whole body know.

This is one of the reasons that mountain tops, stargazing and staring into the ocean have a reputation for calmness. They let you rest while simultaneously evoking awe.

And when you're calm and outside yourself, you can find out what it is you most needed to rest – or recover – from in the first place.

MICHAEL JORDAN'S BASEBALL CAREER

In the pantheon of 'Sports Stories turned Life-Advice Parables', Michael Jordan is incredibly well represented. But when we get to that one bizarre year where MJ played minor league baseball, we get a gap in the Michael Jordan hero-lore. The great basketball player switches codes to play a sport he's not only worse at but that comes with way less perks. Less money, less cachet, less sponsorship deals, less hype – it's a confusing move.

At worst, it's a punchline. At best, a cautionary tale, right? It reminds us that even Michael Jordan can get distracted by shiny new things. Surely this baseball career represents self-sabotage.

It's around here that the life coach might pause in their seminar and ask you, 'So, are you playing basketball or baseball?' You take stock of your life and realise that you're spending all day answering emails instead of becoming the

master puppeteer you were born to be. The puppets are your baseball; the sculpting your basketball. Allegory done. Case closed. Time to win!

Except for one thing ... that's not the story at all.

In 1993, Michael Jordan was on top of the world. He had three NBA championships to his name, his silhouette on a shoe, and more zoot suits than you could shake a shoulder-pad at. He was poised to cement his name alongside greats like Kareem, Magic, Dr J, AI and Larry Bird. All he had to do was keep playing the game he was born to play.

Instead, he shocked the world by announcing that he would now be playing minor league baseball. The media had a field day. But beyond the jokes, the million-dollar question was: *why?*

A few months earlier, Michael Jordan's father, James R Jordan Sr, was murdered. This isn't the kind of thing you bounce back from. This is the kind of thing that destroys your life, splitting your existence into 'before' and 'after'.

My sister is a grief counsellor. After Tinman died, and after a week of crying at the most unpredictable things, I called my sister for advice. She said that there's no one set way to grieve, just like there's no one way to tell a joke, cook a meal or enjoy a long weekend. There's a decent chance the idiosyncratic way you process death won't make sense to anyone but you. Embrace it.

Michael Jordan thought in sport. Following my sister's logic, it's understandable that he would also *grieve* in sport.

When MJ was a kid, his dad was keen on turning him into a baseball superstar. But when every cell in your six-foot-six body wants to shoot hoops, you make a few adjustments. Keep the 'superstar', change the code. Now, being a superstar didn't matter. What mattered was honouring his dad's original dream. So Michael Jordan stepped back from the court, and James R Jordan Sr's son finally played baseball.

That was the year MJ became the GOAT. Not because of his threes, although they are a huge part of it. But because of three other things.

First, he embraced his own definition of grief. Second, he

lowered the level of his stakes, but not his level of activity. Third, Jordan switched back. Recovery, processing and taking a break are all necessary parts of the process, but so are drive, performance and striving.

Intentional rest is a red-hot move. Many greats who have taken calculated breaks have come back even harder. Jordan, as we all know, went on to win three more championships, defeat the Monstars in *Space Jam*, play a decent round of golf, have his crying face become a meme, and be widely regarded as the greatest minor league baseball player to grace the game of basketball.

RECOVERY AND RESILIENCE

When the wind knocks a tree about, its roots expand in the ground to make it more stable. The more a tree endures in its youth, the more it tends to thrive in maturity. This final aspect of winter's rest is the final part of the blooming process. Here we'll be focusing on the things that have knocked us about. We'll get to know them both as a storm and as the source of our most potent growth.

Osher Günsberg was someone I knew from the TV. Growing up, he was the host of *Australian Idol*, going by the name Andy G. I had vague memories of him having some sort of public mental breakdown, going 'somewhere' and returning to Australia happy and with a new name. I was sixteen and thought about it the way a sixteen-year-old boy thinks about things like that, which is to say I didn't. I thought about MSN and handbrake turns.

Osher, meanwhile, was living the story. During his days presenting *Australian Idol*, he spent weekends and nights cultivating a severe alcohol addiction and a bonus drug abuse problem. Before the 'mental breakdown' that I remember in the tabloids, he had lots of little quiet crashes. These were as ripe with sadness as the big one to come, but their clandestine nature made them all too easy to ignore. Every time things got bad, he swore he'd quit – and within days was back being a mess.

Then came the very public breakdown, synced up perfectly with his also public divorce.

Osher left the country and did some soul-searching. By all accounts, he had a complete transformation. He discovered the twelve-step program and sobered up. He had epiphanies about animals and stopped eating them. And he began exercising, the way a newly sober vegan with a shameful past inevitably does.

Now that he had built a solid foundation from which to change, Osher was able to look at his life with much-needed serenity. To use our analogy, this was the part of Osher's story where he brought in an army of worms to turn all his shit from the past into fertiliser for the future. This included a very horrifying pain. When Osher was a child, he was sexually abused. Most victims of this nightmare will never process it, and to demand them to isn't the answer. But when we see someone actually break through and reconcile with such a wound, we should celebrate them as a shining example!

Then, we ought to ask them how they did it. And we ought to remember that their answer will likely be the furthest thing from straightforward.

When I first heard Osher's story, I didn't have the mental acuity to use it. But I was definitely primed for a breakdown of my own. And it was all in a mercilessly ironic context: he had asked me to make him a trigger warning.

Osher had just written a memoir, *Back After the Break*, and was now touring a one-man show, telling the story of his life.

'I'm in my forties, it's a half-time report,' he told me, 'but it's a story I want to tell.'

I had met Osher through Instagram when he had shared a drawing of mine. Our online friendship had become a real friendship, and this was the first job he had asked me to do.

'But it's also a harrowing story, and there's a lot of stuff people might want to avoid reliving if it reminds them of their own trauma,' he explained. One of the first things I noticed about Osher was that he never stumbled or used filler words when he spoke. 'I want a content warning, but I don't want it to feel overly serious, even though it's about serious things, because that's what the show is about!'

He sent me an audio file of a song. It was a ninety-second Tony-worthy glam-metal extravaganza. The lyrics warned the audience of the horrible things that were going to be in the show they were about to see. He asked me to create the visuals.

It's a curious thing to be tasked with creating a trigger warning for something and then get colossally triggered by the proceeding content. But that's what happened.

I went to the show with my partner Felicity and when Osher got to his story about childhood sexual abuse, he sang it as if it were a nursery rhyme. He stood on stage with an acoustic guitar and a gigantic happy grin and bounced through the lyric 'the neighbour in the pool stuck his penis down my throat' to the tune of 'Little Peter Rabbit had a fly upon his nose'.

As an artistic choice, it was both disarming and haunting. The comedy took the edge off, and then the childish melody slapped it back on in spades.

I watched Osher sing this song in front of hundreds of people. At the time I didn't realise what was happening, but this song picked at an old wound. I also had a secret – which, at that point in time, I planned on taking to the grave. Instead of talking to myself, let alone anyone else, I acted the way a soul might act when up against a dream team of addictions and a traumatising nursery rhyme. I got busy obliterating myself. The events of that night are a blur, but Felicity later filled me in. She told me I was mumbling incoherently about that song, and crimes against innocence.

The next day I began a two-month stint of Xanax abuse. And not in a cool way. After two months of living in a haze, I concluded that life was not worth living. I decided I was going to stab myself in the stomach with the biggest knife I could find.

Except I kept getting caught on three things. The first thing, Felicity, made sense. But it surprised me to discover that the other two things were so influential. They were my two dogs. I loved them so much. And I couldn't stop thinking about this Reddit post I saw once: 'If you kill yourself, your dog will have no idea what happened to you.'

So I got help.

I called my mum and began to cry. She asked me if I was crying about a very specific thing that I didn't know she knew about. I said yes and that it was the first time I had told anyone. Mum knew the way mums know everything.

I got off the phone and told Felicity. Felicity knew because apparently I had made allusions to the pain when I'd blacked out over the years and she had connected the dots.

To my surprise, they were not disgusted or angry at me. They didn't love me less.

Then I did something I never thought I'd do. After being sectioned, I had sworn off talking to mental health professionals. Yet nine years later, I started therapy.

I also called up Osher and told him the truth too. It's strange to tell your darkest secret to a prime-time television host you've grown up watching. It's even stranger when that TV host helps you process it. Osher became a mentor, helping me work through that trauma and then get sober.

Around my thirtieth birthday, I did something radical. This secret had haunted me for long enough. To strip it of its power I decided to share it with the world. I spoke about being sexually abused as a child, straight down the barrel of my camera, and uploaded the video to YouTube. This was one of the most liberating things I've ever done. I blasted the shadow that had haunted me for years with daylight.

I received many heavy messages from others who were suffering in the same silence – some were from friends, but most were from people I didn't know. What hit me in that moment is how feelings of isolation are about as unifying as life gets. There isn't a single person on this planet who hasn't felt alienated for something.

In winter, we're more likely to get sick, rug up, stay home and withdraw. But how solo is solitude when everyone is doing it?

You might be in your own winter right now. Maybe you're resting well; maybe you're resting poorly; maybe you're resisting your body's desperate rest requests altogether. Taking a moment to recover is as natural and needed as the seasons. But there's no denying that stepping back from the swing of life can make you feel left out.

Imagine standing outside an apartment building on a cold night. You can see dozens of illuminated windows. In these separate boxes, you catch glimpses of people living their life apart. But the further you step back, the more the individual lights blur into one. With some more distance, you can make the

whole city look like one light. Take this to its extreme, and you're looking at all of Earth from space. All lights blur to form everything we've ever known.

If you are feeling withdrawn from the world, I want you to know that you're not alone. Sincerely, though. The phrase 'you're not alone' has lost most of its sting, but the concept it's getting at is nothing to dismiss. It's the idea that even in your darkest moments, and indeed because of your darkest moments, you're still part of the light.

MENTAL CHILLNESS

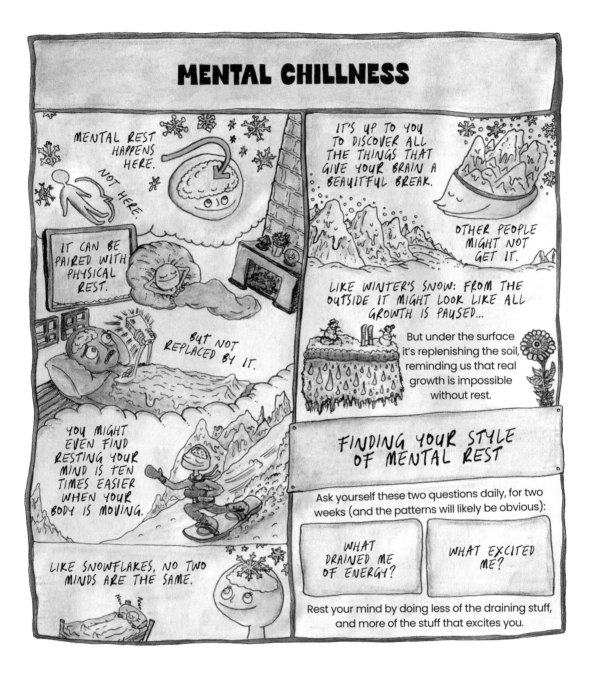

MENTAL REST HAPPENS HERE.

NOT HERE.

IT CAN BE PAIRED WITH PHYSICAL REST.

BUT NOT REPLACED BY IT.

YOU MIGHT EVEN FIND RESTING YOUR MIND IS TEN TIMES EASIER WHEN YOUR BODY IS MOVING.

LIKE SNOWFLAKES, NO TWO MINDS ARE THE SAME.

IT'S UP TO YOU TO DISCOVER ALL THE THINGS THAT GIVE YOUR BRAIN A BEAUTIFUL BREAK.

OTHER PEOPLE MIGHT NOT GET IT.

LIKE WINTER'S SNOW: FROM THE OUTSIDE IT MIGHT LOOK LIKE ALL GROWTH IS PAUSED...

But under the surface it's replenishing the soil, reminding us that real growth is impossible without rest.

FINDING YOUR STYLE OF MENTAL REST

Ask yourself these two questions daily, for two weeks (and the patterns will likely be obvious):

| WHAT DRAINED ME OF ENERGY? | WHAT EXCITED ME? |

Rest your mind by doing less of the draining stuff, and more of the stuff that excites you.

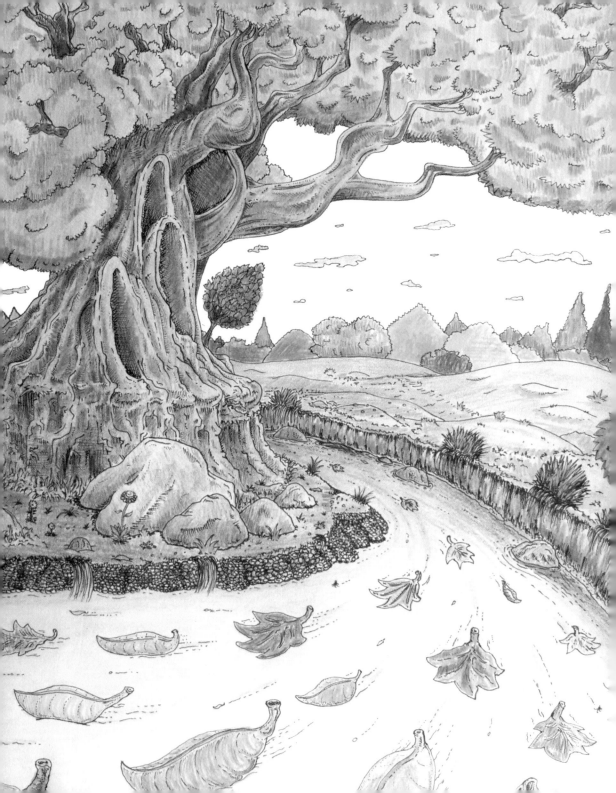

CONCLUSION

SOME THOUGHTS ON LIFE AND CLOWN/POETS

WHEN I READ THAT HE BURST INTO FLAMES, I FELT PHYSICALLY SICK.

I was combing the internet for confirmation, hoping that an official police report or a death notice would help me stomach the reality of it all. Tinman had deleted his social media accounts, as if to disappear completely, and all I could find was a local newspaper article.

There wasn't much to it, just a handful of sterile sentences: 'Man dies in fatal car crash,' and so on. The final sentence, however, said that both the man and his car caught on fire on impact, and that Tinman was burned inside.

I started dry retching. I couldn't get the image out of my head. You'd be hard-pressed to find someone who hadn't had intrusive thoughts of ghastly tableaux, akin to the image of an immolated person inside a car. These mental horror flicks are terrifying, don't get me wrong. But when the source material shifts from a hypothetical catastrophe to your friend's grotesque death, intrusive thoughts get an upgrade. This new image was something that actually happened, and couldn't unhappen. Every flash of flames was gut-wrenching.

I didn't talk about the fire much with anyone, and I didn't plan on including it in this book. But when I sent the manuscript to Tinman's brother to read, we naturally found ourselves talking about the final details of his life.

'I saw it,' his brother told me. 'Just after it happened, I drove there and I saw it. Him and the car both just caught on fire ...'

'Man ...' I didn't know what to say – does anyone? 'Does the image of it haunt you?'

He paused and thought about it. 'Actually, no. Not at all. If I hadn't seen it with my eyes, I would definitely have made it out to be way worse in my mind. Other people who didn't see it seem to have had a harder time with it. But because I saw it, all the bad stuff was just, I don't know, right there in front of me.'

THE LIGHT AT THE END OF THE TUNNEL

As we come to the end of our adventure, I'd like to pose the most fundamental of questions: what do you want?

You might have an answer or you might not. You might have a different answer tomorrow than you did yesterday. But I'd like to leave you with *my* answer, not from today but from when I was a kid. I wanted to be a clown and a poet. At the same time.

I had two reasons for wanting to be a clown. First, when a clown runs and then stops, their baggy costume keeps going for a split second, and it makes all their physical movements cartoony as hell. I wanted that. Second, I wanted to swing on the trapeze. It never occurred to me that acrobats had a different skillset: I just figured they doubled as clowns.

My drive to be a poet was equally, if not more, calculated: I really liked rhyming. Poets, from what I could tell, rhymed for a living.

Paired with a clown suit and high ropes, this felt like a solid career plan. In the words of Confucius, Einstein, Twain, Wilde – or maybe it was Churchill? – 'Choose a job you love, and you'll never work a day in your life.'

I wouldn't encounter the reality of the market's scant demand for clown/poets for a few more years, so the hours I spent writing poems and doing flips felt meaningful. 'If I keep up all this rhyming and tumbling,' I'd think, 'I could get good. Hell, I might even get a job in the circus/poem factory!'

This was my version of that kid thing where you pretend you're singing to the judges on a talent show, then the mean judge uncharacteristically leaps out of her chair and declares, 'I don't know what *it* is, but kid, you got *it*!' Or, when you're shooting hoops, and you fantasise that Michael Jordan (on break from baseball practice) will be driving around your neighbourhood, see you drain a three and give you a scholarship to some magical basketball academy.

This hope is beautiful. It keeps us learning how to sing, shoot hoops, and write poems on the trampoline. What makes this hope so pure is how little impact the outcome has on it. The dream is a north star, and it fuels us.

But as we grow up, while we continue to have certain goals, we also start to need a few things. The reality of meeting your needs as an adult starts informing the practicality of your dreams. We filter out the symbolic stuff and narrow in on the paths we think are possible. This is mostly a win. Instead of putting all my energy into becoming a clown/ poet, I learnt to put it into a job that actually existed. This practicality has made my life infinitely better.

But you know what else is mostly a win? Russian roulette.

The drawback is that we are held hostage by what we consider possible.

It might be unrealistic that Michael Jordan would ever drive through your Australian country town looking for a ten-year-old prodigy. But is it realistic to think of yourself as stupid? If you flunked a few tests, had a nasty teacher and an overachieving cousin, you might start building a case against your own intelligence. Even though you adore the stars, you think it's sensible to rule out a career in astrophysics. That's a path reserved for smart people. Chasing that dream is an invitation to have your hopes crushed. Better crush them now before you get attached.

As we draw to the conclusion of this book, you might hear this kind of grown-up voice creep back in: the tidied-up voice that, like Doom, conflates uncertainty with fear. I hope at some point along this journey you also heard the voice of hope: the call of Bloom, that sees the unknown as an exciting opportunity.

If you did hear this second voice, I encourage you to nurture it. And, if you're up for it, I encourage you to nurture your pessimistic grown-up voice too. Let creativity sit in the driver's seat, but make sure self-destruction doesn't feel forgotten. As the voice of Bloom turns your life into an adventure, give the voice of Doom the role it so desperately wants. Ask it to tell you you're going to fail.

What? Isn't this meant to be the inspiring conclusion?

Whatever you're doing, ask the voice of Doom to tell you you'll fail – *on one condition*! It also has to tell you you'll fail at everything else. Whatever *else* you could be doing with your time, whatever other options your inner saboteur suggests, whatever fearful Plan B Doom tries to talk you into, make sure it admits that quitting won't change the outcome. It's taking the question, 'what would you do if you knew you couldn't fail?' and flipping it. What would you do if you knew you'd fail at everything?

We're not asking this because you're going to fail. And besides, you didn't need to know that an outcome was guaranteed to chase it when you were a kid. We're asking this question to remove the influence that Doom has on how we live our life. By imagining every path leading to failure, the fear of failure loses its power to steer us in one direction or the other.

The forces that pull us into dark and terrified places have godawful leadership skills. To give them any say in big life decisions is like driving a car by flooring the accelerator, closing your eyes, and taking your hands off the wheel so you can cross your fingers and wish for the best.

Doom is not a thinker, but a reflexive feeler. It says, 'You're going to fail, so do something different.' Then, when you try that different thing, it's back again with the same line, as if 'something different' will actually be something different. As though the task is responsible for these mental patterns, and not the fact that they're just doing what patterns do best: repeating themselves.

Every time we stare Doom in the face, we build a new pattern that finds Doom the way Dante found the devil. Not as some big evil supervillain, but as something to be pitied. When we ask our inner critic to be logically consistent, or to cite its sources, or demand that it first answer a handful of why's, we realise it was never a monster at all.

Doom is just a shape in the shadows, and shadows don't survive the spotlight. Stare at it, interrogate it, poke it, prod it, and put it under big bright lights and watch Doom vanish.

And when it does, take a deep breath, and watch your world Bloom.

AN APPENDIX

It's easy to be wary of life lessons taken from people who later ended their own lives. But this is the advice that kept a tortured person around for so long. The ideas left behind from people like Sylvia Plath and Anthony Bourdain are ideas from people who were playing on hard mode. For this reason, I believe their words have a special weighting. And so, along with the drawing that I did for Tinman's funeral and that sparked my journey into creating this whole book, I'm sharing here a manifesto that Tinman wrote, which will hopefully help you on your journey from Doom to Bloom.

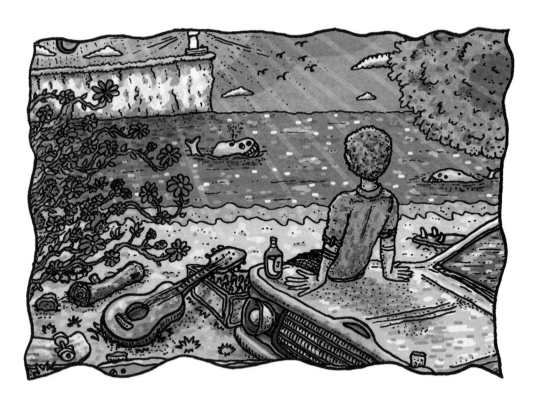

DO SHIT: A MANIFESTO BY TINMAN

Life is simple. There's really only one decision to make.
Either do nothing much or do some shit.

If you choose to do shit, you'll find all sorts of passionate people doing all sorts of amazing shit. People who play shit, drive shit, build shit, knit shit, invent cool shit, hit shit, design shit, truck shit, do sciencey shit ...

You'll find people who are alive, people who are doing, and – perhaps most importantly of all – you'll find people who see cool shit where most people see shit all.

It's up to us to find them and share them and the shit they're doing with other people who want to be inspired to make every second of their lives count, rather than arriving at their inevitable deathbed having done nothing more than log over forty zillion hours of television-watching, inane snapchatting, and posting pictures of moderately delicious meals.

You are here. Here is a precious gap, a miraculous crevice, an unlikely slice of existence. We are precariously sandwiched between the epic slab of time since the birth of the universe and the ten more slabs of time about eighty years from now, where you'll go back to being a bunch of random things that are – in all likelihood – infinitely less able to do shit than you are.

We believe doing shit is contagious. When we see somebody else doing amazing shit, it makes us wonder what amazing shit we are capable of.

So when these words finish, maybe put your phone away, put your computer away, put your fears and your excuses away and go do some shit.

— *TINMAN, 2014*

ACKNOWLEDGEMENTS

First things first, thank YOU. Yes you, the person holding this book. I don't know who you are but I know that I've spent the past year writing something for you, and for what it's worth, I've really cherished the parasocial friendship I've had with you. When the words felt wrong, I thought about how I wanted to give you something better. When the words felt right, I imagined you reading them and feeling what I felt. And when the whole thing became a chaotic whirlwind of caffeine jitters, synonyms and all-night illustration marathons, the idea of you being on the other end gave it all meaning. So thank you. Seriously.

There was a lot going on in my life when I wrote this, and if I'd had to deal with it alone I would have crumbled into a fine mist under the pressure. Mum, you're the best. I'm so grateful to finally be living near you. Your love and support has allowed raising a family and book-sized creative projects to comfortably coexist. Same goes for the rest of my whānau and the Handleys. I love you all. Dad, thank you for helping me through hell. You're one of a kind and I couldn't ask for more.

To Gator for the dad-chats, the constant chess and being a partner in sobriety, to Benny for the therapy and laughing fits, to Bryce for the voicemails and venting, to Eric and Fi for the parenting parallels, to Avalon for the depth of our friendship – tysm.

To Kyle and your family, thank you for everything. I hope this can pay a few things forward. He was a deeply formative part of my life and I'm so sad he's gone. Thank you for letting me tell his story.

To my team: Alice, Ant, Tahlia, Kirstie, George and Emily. You have been so patient with my chaos. And beyond all the talent and empathy, you're all just lovely people to create with. Thank you. To Osher for helping me through some of the hardest things I've ever been through. To Matt for being where I'm at. To Jono for being a rock. To Cameron for your mind. And to Sarah for showing me what's possible.

And finally, the thank you to end all thank yous to my wife Felicity and my daughter Zelda (and your brother when he gets here). You're my world. The other day I got a YouTube comment that said, 'I dont wanna downplay your experience but hands down ... Getting a goth wife is like 50% of what fixed your life, I am so happy for you man.' He was wrong. It's 100%.

Published in 2025 by Hardie Grant Books,
an imprint of Hardie Grant Publishing

Hardie Grant Books (Melbourne)
Wurundjeri Country
Level 11, 36 Wellington Street
Collingwood, Victoria 3066

Hardie Grant North America
2912 Telegraph Ave
Berkeley, California 94705

hardiegrant.com/books

Hardie Grant acknowledges the Traditional Owners
of the Country on which we work, the Wurundjeri
People of the Kulin Nation and the Gadigal People
of the Eora Nation, and recognises their continuing
connection to the land, waters and culture. We
pay our respects to their Elders past and present.

A catalogue record for this
book is available from the
National Library of Australia

Doom and Bloom: The Case for Creativity in a
World Hooked on Panic
ISBN 978 1 76145 056 3
ISBN 978 1 76144 322 0 (ebook)

10 9 8 7 6 5 4 3 2 1

Publishers: Tahlia Anderson, Alice Hardie-Grant
Head of Editorial: Jasmin Chua
Project Editor: Antonietta Anello
Editors: Kirstie Innes-Will, Emily Hart
Designer: George Saad
Creative Director: Kristin Thomas
Head of Production: Todd Rechner
Production Controller: Jessica Harvie

Colour reproduction by Splitting Image
Colour Studio
Printed in China by Leo Paper Products LTD.

FSC
www.fsc.org
MIX
Paper | Supporting
responsible forestry
FSC® C020056

The paper this book is printed on
is from FSC®-certified forests and
other sources. FSC® promotes
environmentally responsible, socially
beneficial and economically viable
management of the world's forests.